Home and the World

Focus on African Art

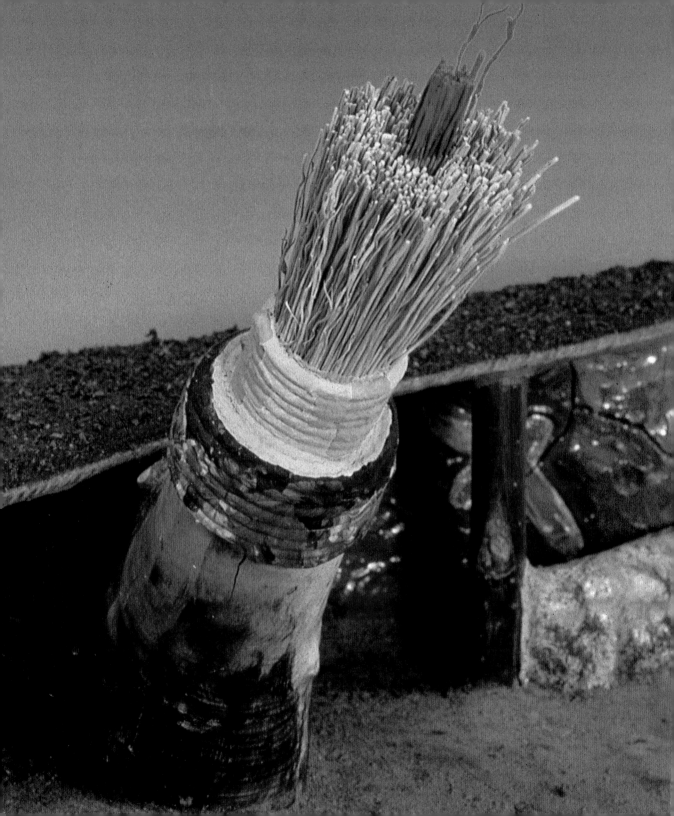

Home and the World

Architectural Sculpture by
Two Contemporary African Artists:
Aboudramane and Bodys Isek Kingelez

Contributors:

Ismail Serageldin

Celeste Olalquiaga

Jean-Louis Pinte

Jean-Marc Patras

The Museum for African Art, New York
Prestel, Munich

Home and the World is published in conjunction with an exhibition of the same title organized and presented by The Museum for African Art, New York.

Text editor: David Frankel
Design: Linda Florio Design
Publication coordinators: Carol Braide, Bettina Horstmann

Trade edition distributed by Prestel-Verlag, Mandlstrasse 26, D-8000 Munich 40, Federal Republic of Germany, Tel. (89)38-17-09-0; Telefax (89)38-17-09-35. Distributed in continental Europe by Prestel-Verlag, Verlegerdienst München GmbH & Co. KG, Gutenbergstrasse 1, D-8031 Gilching, Federal Republic of Germany, Tel. (8105)2110; Telefax (8105)5520. Distributed in the USA and Canada on behalf of Prestel-Verlag by te Neues Publishing Company, 15 East 76th Street, New York, NY 10021, USA, Tel. (212)288-0265; Telefax (212)570-2373. Distributed in Japan on behalf of Prestel-Verlag by YOHAN Western Publications Distribution Agency, 14-9 Okubo 3-chome, Shinjuku-ku, J-Tokyo 169, Tel. (3)208-0181; Telefax (3)209-0288. Distributed in the United Kingdom, Ireland, and all other countries on behalf of Prestel-Verlag by Thames & Hudson Limited, 30-40 Bloomsbury Street, London WC1B 3QP, England, Tel. (71) 636-5488; Telefax (71)636-4799.

Library of Congress catalogue card no. 93-78246
Paperbound ISBN 3-7913-1326-6

Front cover: Aboudramane, *La Grande Mosqueé* (The Great Mosque), 1991, mixed media with wood, straw, 42 x 36 x 39 cm.

Printed and bound in Japan.

Acknowledgements

More than most, this authorless exhibition and catalogue result from the contributions of many people. The main execution of the project and the assembling of all the elements necessary to the exhibition and catalogue were accomplished by Bettina Horstmann who organized the loans, contacted the writers, and collected the catalogue illustrations. David Frankel edited texts, wrote captions, and helped us identify this interesting group of writers. Translations from the French were made by Bettina Horstmann, Jeanne Mullin, and David Frankel. Jean-Marc Patras not only lent to the exhibition but wrote about Bodys Kingelez, and assisted us in the difficult task of communicating with the artist in Kinshasa. Yvonne Senouf of Cavin-Morris Inc. in New York facilitated our early contacts with Aboudramane, while Catherine de Clippel in Paris kindly took portrait photographs of the artist for this project. Aboudramane himself was helpful in arranging for the photography and shipping of his work, and was most generous in lending his sculptures to this travelling exhibition. Nguyen Tien Lap photographed all the exhibition objects in France. Jerry Thompson photographed "La Grande Mosquée" with his usual sensitivity. Linda Florio created the design concept for the *Focus* book series and produced this catalogue. As often before, the incomparable Carol Braide supervised all the various elements of the publication. I am most grateful to them all.

S.V.

Foreword

This publication marks the beginning of the Museum for African Art's new series of books and exhibitions, *Focus on African Art*. The *Focus* series will examine in depth smaller topics than those treated in our major books and exhibitions. Both deeper and narrower in scope than our other presentations, the *Focus* books will take a penetrating look at a wide spectrum of subjects, ranging from an occasional examination of single issues in contemporary African art — as here — to isolated characteristics of Africa's great artistic heritage.

"Home and the World" gazes at that heritage and looks into the future. In their different ways, both Aboudramane and Kinglelez's sculptures comment upon the present and future of Africa's artistic enterprise. Aboudramane is concerned with loss, and gives us the ever-changing memory of a traditional past already modified by his visions of other architecture. His uninhabited buildings look lived in, but by people who have gone and may never come back. Aboudramane's work gives no inkling of what may have become of them. Kingelez' resolutely modern buildings have banished every trace of traditional African architecture and life. But they are also empty perhaps because the people who would know how to use them have not yet been born. The buildings bear not the slightest hint that any local activity might take place in them. Unoccupied but not abandoned, they are forever brand new and waiting.

Aboudramane and Kingelez, who are from different parts of the continent, have never met and may not be aware of each other's work. But the highly original direction each has chosen signals the emergence of new African art. No longer anonymous, ethnographic, or local, these

artists are already experts in negotiating the cultural shoals that increasingly face us all. Thrust at birth and without their consent into a "multicultural" world, Aboudramane, Kingelez, and their age-mates became instantly multilingual and fluent in the ways of Africa and the West. They confidently use the mingled vocabularies of many visual traditions to create artworks that speak in voices clearly their own. As living African artists begin to emerge on the international scene in ever greater numbers and with growing success, the Museum for African Art is proud to introduce these two outstanding artists to a wide American public.

Susan Vogel
Executive Director

Contents

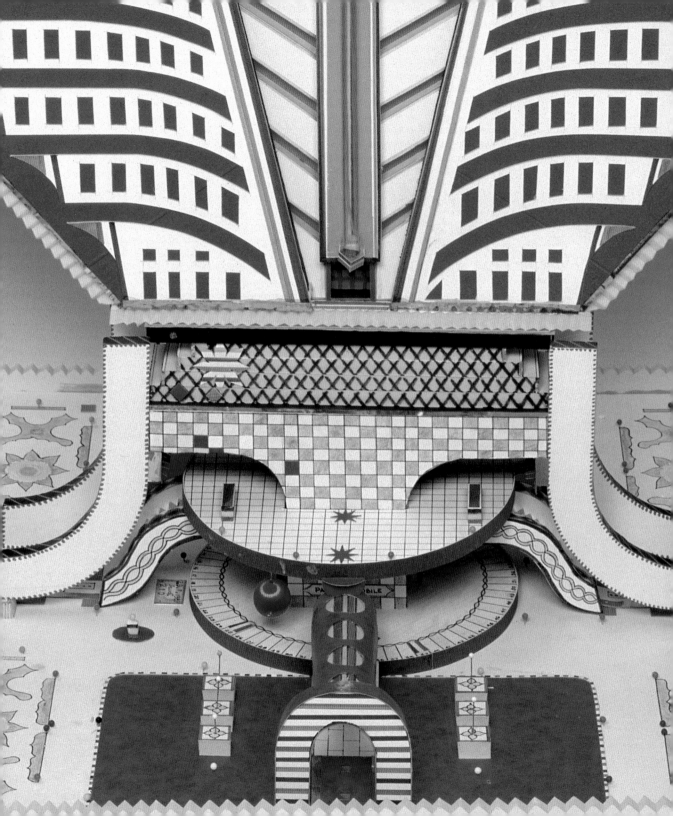

Home and the World: Architectural Sculpture by Aboudramane and Bodys Isek Kingelez

We live in a confusing world, a world of crisscrossed economies, intersecting systems of meaning, and fragmented identities. Suddenly, the comforting modern imagery of nation-states and national languages, of coherent communities and consistent subjectivities, of dominant centers and distant margins no longer seems adequate. . . . we have all moved irrevocably into a new kind of social space.
　　　　　　　　　　　　　　—*Roger Rouse,* **Diaspora**, *Spring 1991*

Yes I am very African, because Africa is above all amalgamation and recycling.
　　　　　　　　　—*Fode Camara, a Senegalese artist who lives in Paris and Dakar*

"Home and the World" focuses on the work of two contemporary artists from Africa, each expressing distinct and highly personalized visions in three-dimensional form. The exhibition examines their sculptures against the background of the increasingly heterogenous cultural context in which much contemporary African art is produced, for the existing conceptual frameworks that interpret this art solely in relation to Africa's geographical boundaries are increasingly inadequate. The limitations of a preconceived identity bound to a singular, monolithic, homogenous "African" space are especially problematic when we note

that in recent years Africans in search of new opportunities and experiences have intensified their movements back and forth between home and abroad. The two artists in the exhibition, for example, operate transnationally, traversing multiple economic and cultural zones in support of their work.

Aboudramane was born in Côte d'Ivoire. He left home in the 1970s for an unsuccessful soccer career in Italy and later moved to Paris, where he currently lives and works. Bodys Isek Kingelez, though based in the Zairian capital of Kinshasa, travels and exhibits widely in the major metropolitan centers of Europe. Recognizing today's global interdependency, both Kingelez and Aboudramane are reworking cultural contours and practices and tracing new ones, selecting, reconfiguring, and preserving those points of view important to them. The result is an opening up of Africa's cultural terrain, allowing for more personal and singular responses. "Home and the World" portrays these artists' two very different aesthetic strategies at work.

Aboudramane's sculpture incorporates a range of forms drawn from an eclectic gathering of traditional-African and Western architectural styles. The artist extracts and re-presents elements of a variety of buildings (churches, mosques, secular dwellings), reshuffling and mixing-and-matching indigenous traditional forms into a carefully distilled blend that also includes traces of Islamic and French-colonial architecture. If Aboudramane is involved in a process of transforming and reimagining a past, Kingelez is more engaged with the present. In visionary postmodern bricolages that playfully merge fantasy and reality, he has invented a polyglot vocabulary of architectural styles drawn from high-tech postindustrial design, the modern Afrocentric skyscrapers of downtown Kinshasa, traditional Asian pagoda forms, and pre-*glasnost* Soviet-style modernism. These elements are among the

global fragments that make up his eclectic historical and architectural coalition.

Despite highly individualistic and contrasting practices, these artists have much in common. Their choice of architectural sculpture as a form, for example, is part of a perceptible shift in contemporary "African" art away from painting on canvas. Both artists are careful not to limit their creative capacity; in subtle and not so subtle ways, each of their buildings incorporates a range of possible identities shaped not only by personal experiences but also by the various cultural influences and intersecting histories that make up postcolonial Africa.

As this exhibition sets out to demonstrate, the architecture of identity begins with individual acts of self-representation. Both Kingelez and Aboudramane demonstrate the capacity to imagine, define, and renegotiate their own coexistence with the world at large. In this sense the buildings represented here function not only as decorative objects but as shelters, portable repositories for identities in the making.

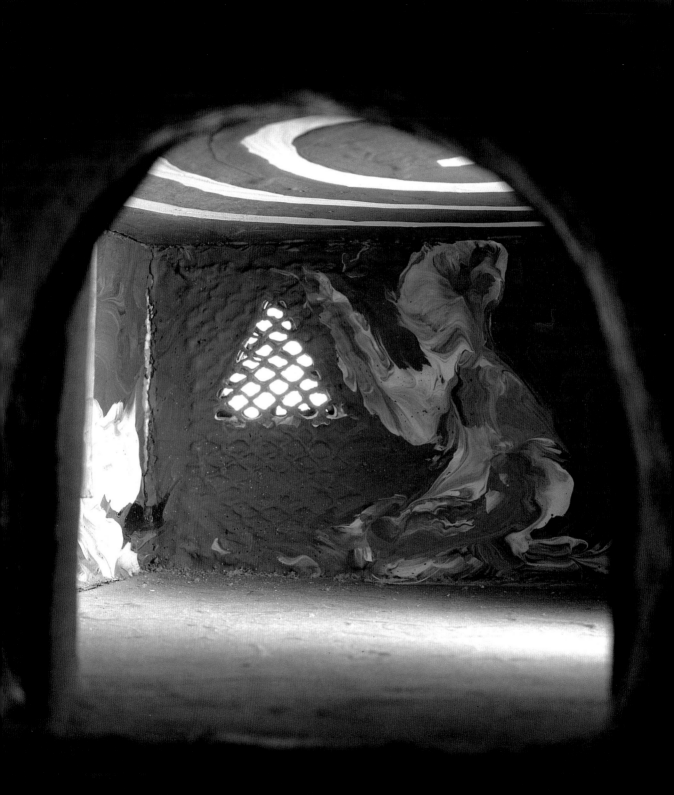

Home is Where the Art is

Celeste Olalquiaga

In postmodernity there is, quite literally, no place like home. Redefined by the disintegration of centralizing institutions like family and nation, infiltrated by an electronic world whose quotidian presence has erased the distinctions between exterior and interior, and intermittently abandoned and reoccupied through a permanent migratory flux that has created a new, nomadic culture, home — that territory of imaginary belonging from which both personal and collective identities once were drawn — is no more.

As borders are continually redefined by war and technology, space, both elusive and ubiquitous, is no longer susceptible to circumscription. The organic entitlement once legitimized by origin—a birthplace, an ancestral abode—has perished; what determines the fundamental aspects of being is experience. Habitats have ceased to be sacrosanct arenas of cohesion, microcosms for an exclusive sense of affiliation that would expand concentrically from individual homes onto towns, cities, countries, and continents. And the hearth, with its suggestion of a ritualistic fire providing warmth and community amid a

Aboudramane, interior of
La Grande Mosquée (see p. 38 – 39).

15

dark and solitary vastness, has become a tired metaphor — a leftover image that speaks of unity only in the extinct language of preindustrial times.

Nowadays, homes are made instantly from scratch in the seams of the very social structures that used to support them: market carts, subway stations, park benches. Refugees, exiles, boat people, and the homeless are the children of the twentieth century, the rightful citizens of the twenty-first. Made in transit, their homes are located strictly in the present, in the very moment in which they provide shelter. The sense of continuity that would enable the projection of these makeshift dwellings into the future, or would allow them to moor an existential process in time, is gone.

The postmodern home is not contingent on a spatial and social stability determined by fixed boundaries, patriarchal hierarchies, or even a prevalent culture. On the contrary, it is created in a realm that, too often in the past, homes stood for without constituting: the site of affection and solidarity, the intersection of need and desire across race, gender, sexuality, and sometimes also class. Freed from emblematizing the extinct discourses of kindred perpetuation and national integrity, the postmodern home is the product of their formal implosion. Like an incomplete jigsaw puzzle, the shattered remains of this contraction are assembled in vain.

Deracinated and volatile, postmodern homes expose and redress the imaginary underpinnings that once privileged the dwelling as the heart of culture, as the material equivalent of identity. In the West, a culture divided into public and private spheres, home came to mean intimacy and protection, the site of individuality. In the East, home was the last bastion of millenary traditions, a refuge from the incessant attack of modernization. For both, home was the last territory to be

penetrated, a feminized, domestic space where women and children —
the guarantors of a tomorrow — were to be kept from the outside
world. Today, this notion of home endures solely as an icon of itself;
home is now a nostalgic yearning, a burning desire for a romanticized
sense of belonging whose segregative appeal is apparent in the current
resurgence of fanatic nationalisms.

It is from this deterritorialized notion of home that Bodys Isek
Kingelez and Aboudramane project their architectural fantasies,
crafting them respectively as mythological emblems of a future that
never came and of a past that never quite was. Using memory as a visual
trope for their respective processes, both artists move back and forth in
time and space, fortuitously drawing a transcontinental loop: tracing the
inspiration for his radical maquettes to a simple photograph seen in
passing in an old European magazine, Kingelez builds his miniature,
colorful modernist empires in Kinshasa, Zaire; making his topic the
distant reminiscence, Aboudramane creates rural Côte d'Ivoire houses
amidst the metropolitan decay of faraway Paris.

Baroquely elaborate or minimally austere, public or residential
in spirit, the architectural sculptures of Kingelez and Aboudramane
intersect in fetishizing an imaginary space (a photo, a souvenir) that
they then transform into a two-way mirror of their own colonial
inscription. Their buildings become ports, places of multiple
transactions, where the subject adjusts to the demands of a cultural
economy whose driving desire is dislocated: to be is not to be, but rather
to see oneself from another moment and place. In this way, Kingelez
gallops on a floating image of a *Papillon de mer*[1] into the sunset of
modernity, while Aboudramane conjures, from an urban remove, the
rustic architecture of his remote Côte d'Ivoire. Yet neither Kingelez's
futuristic constructions nor Aboudramane's organic Africa correspond

directly with reality. Instead, they iconicize different moments of colonial displacement — utopia and nostalgia — by way of an exaggerated or decontextualized representation: Kingelez's hyperbolic versions of modernism's spatial feats, Aboudramane's sculptural renditions of dwellings of an irreducible simplicity.

The two artists display both modernity and tradition as cultural creations, the products of specific social circumstances that demand either a pushing forward in a quest for expansion or a looking back in search of familiar ground. Modernity was aerial and celebratory, eager in its unbounded optimism to soar upward, defeating gravity and the weight of history. It swept apart whatever stood in its way, subordinating all cultural languages to the one-dimensional imperative of industrial progress: move forward, at all costs; never look back. Tradition, in contrast, cherishes the safety of its institutions, fearful of any change that might alter the balance of its sempiternal arrangements. It discards all novelty as a deadly poison, clinging fiercely to the past. Modernity disguises with its audacity the violence of its pitiless erasures; tradition legitimizes its stultification by inscribing itself as "natural." Thus the first world sees itself as a motor force, an engine that can open the way into a seamless universe of automated perfection, leaving Africa to provide the anchorage of a raw referentiality, the nurturing juices of a "mother nature" without which the Western machinery would simply not take off.

Trapped between a stagnant past and an unattainable future, third world cultures resort to collapsing them in an already overloaded present, producing unflinching portrayals of the contradictions that so inexorably bind them. Kingelez uses the modernist theme as a springboard for a cinematic cityscape where architectural codes happily mix; this is the bright version of *Blade Runner*'s bleak cosmos. Filled

with hopeful allegories in the manner of elaborate wedding cakes, imagery and desire join hands in his maquettes, ready to fly off to transcultural bliss on the wings of an extraordinary sea butterfly — the only way this could possibly happen. Performing the exact contrary movement, Aboudramane focuses on the most primal elements of an essentializing tradition: home, church, fields, and marketplace are the signposts of an interiority that wishes, against all odds, to remain ultimately inalienable.

Kingelez and Aboudramane present two modes of dealing with the question of how to be at home with — or despite — colonialism and global capitalism, an issue of primary concern in postmodernity. Their art shows that no matter where you stand, home can no longer be taken for granted; space is not a neutral territory on which particular needs and desires can be gratuitously inscribed. As these artists approach it, the complex language of architecture freezes in time the layered cultural circumstances that constitute it, so that it becomes a scenario, a diorama, of their own subjectivity. We seldom think of our homes except when away from them; it is precisely in their absence that we produce objects that can fill in the void of this lost experience.

1. This is the title of a Kingelez work.

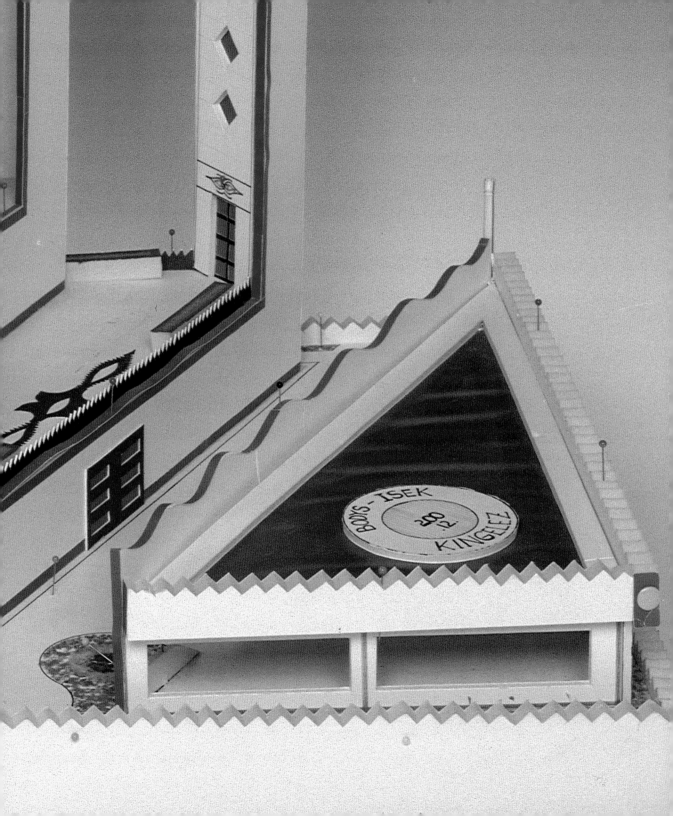

Cultural Continuity and Cultural Authenticity

Ismail Serageldin

Few issues affect contemporary African societies as deeply as a sense of lost identity and a corollary search for cultural "authenticity."[1] For many, this search entails a return to the roots of the precolonial African heritage, in the belief that if the culture could be redefined in its "essential" terms, it would be purged of the extraneous elements introduced by history and Western hegemony. But others see this approach as narrow, romantic, and fundamentally ahistorical: we must indeed remember the past, but we must also decode its language through our own eyes, sifting the relevant from the timebound. The arsenal of contemporary analysis must be brought to bear on the reality of African history as much as on the reality of African societies today. Slavery and colonialism wrought a profound historical rupture in Africa's social and cultural fabric; we must come to grips with this rift in the evolution of African culture, and, by better understanding it, learn to transcend it.[2]

Although the approach I envision is as systematic as Western science, it would avoid the scholasticism of much Western academic

research. It would, for example, explore and revitalize African myths and images to nourish the creative imaginations of the continent's artists and architects, helping them develop their iconography and enriching the symbols that punctuate their universe. Most importantly, it would ground these expressions of culture in a deep, unhurried understanding of the essence of the culture in all its myriad manifestations, past and present.

Artists who struggle with integrity along such a path are unlikely to slip into the doomed attempt to escape a chaotic and unsettling present by a flight toward a romanticized past, or into the equally shortsighted approach that equates modernity with the wholesale import of Western technology, aesthetics, and behavior. The former choice is slow suicide, for no community can isolate itself from the present, no matter how difficult that present may be. And the latter constitutes an agonizing negation of self and identity, since no society can exclude its past from a crucial place among the constituents of its current reality.

Contemporary African art is already extremely rich. Despite the complexity of the field, however, it is still possible to trace among the more thoughtful of today's African artists a consistent, careful attempt to reinterpret traditional idioms to make them meaningful for contemporary eyes. Many of these artists have links with "international" art,[3] but, at the same time, they are opening the way to a necessary critical reinvestigation of the meaning of being African now. After all, despite the specificities of the African experience, contemporary Africa is part of an interlinked, interdependent world.

The two artists featured in this exhibition — Aboudramane, from Côte d'Ivoire, and Bodys Isek Kingelez, from Zaire — offer exceptional examples of the effort of contemporary African artists to

articulate and reflect on this condition. Their unusual medium, architectural sculpture, lends itself to easily recognizable visual references, so that their objects unequivocally echo reality; but they enrich it in the process. At first blush, both of these artists' works can give the deceptive impression that one is seeing a model of a real building, presumably a functioning actuality, or at least a proposal for one. Architecture, of course, must retain a social and functional role,[4] whether built with or without architects.[5] But architectural sculpture is liberated from such restrictions and can push form, texture, and color far into the realm of the imaginary, as it does in these artists' hands. At the same time, intimations of its "real" life distinguish it from the "art of the personal object," and from everyday objects.[6]

Aboudramane's works marry basic architectural forms and traditional African decorative elements, with their bold primary colors and simple geometries. The combination produces images that seem timeless yet specific, evoking both the archetypal structures of African villages[7] and the houses of modest city neighborhoods. Modernity and tradition coexist unself-consciously in both cases;[8] the high-tech Western world has reached the most distant African villages. But Africa, too, has asserted its legacy[9] in Aboudramane's works, which are not bound by geography, national boundaries, or cultural stereotypes.[10]

Kingelez's works are more complex designs, imaginative bricolages of the architect Pierre Goudiaby's buildings (scattered throughout West Africa) and of the strident excesses of postmodernist pastiche by which today's African cities display their contemporaneity. In evoking these "flagships of modernism," Kingelez comments effectively on the polyglot nature of the myths, images, and stimuli that feed the contemporary African imagination.

Each of the two artists represented here addresses the problems

of Africa's contemporary reality differently. Like many other artists, Aboudramane searches to reassert something "essential" and "timeless" in the African heritage, but he refuses simply to copy past forms of artistic expression, a process of debasement we find in so much "airport art" — art for tourists. That kind of mindless copying is a characteristic of the flight toward a romanticized past. Aboudramane's work, on the other hand, attests an effort to abstract parts of Africa's architectural heritage and to recombine its most appealing and relevant elements into new meanings. So far as I know, none of the sculptures in the present exhibition is an exact copy of any existing structure. Each shows not "what was" but "what could be." Again, it is important to underline that because these are sculptures, not architecture, they are delinked from a specific location or function, allowing them more general messages in the articulation of a new aesthetic reality for contemporary Africa.

By contrast, Kingelez's work is full of postmodernist irony. Indeed, his sculptures carry the imported forms of modern African architecture to extremes, challenging the premises that underlie the creation of the urban environment we see in many African cities today. Kingelez challenges the contemporary not by patiently translating a past aesthetic into modernist terms, but by pushing the modernist aesthetic, which is without cultural roots in Africa, to the ironic fringes of postmodernist bricolage. Here the intellectual and the aesthetic challenges are joined: by showing us the outer limits of the possibilities of a part of the African reality, Kingelez forces us to look beyond the simplistic solutions that equate modernity with Western technology, aesthetics, and behavior.

The work of the two artists is therefore complementary. Attacking the same issues from different angles, each brings a new

insight to the *problématique of* artistic expression in African culture today. In contrasting but complementary ways, Aboudramane and Kingelez address a rapidly evolving reality. Their bold aesthetic strategies, which will enrich the artistic vocabulary of their contemporaries and successors, reflect the struggle to assert a unique African identity that is nonetheless organically joined to an evolving contemporary world. These works are an important part of an artistic adventure that is still far from complete.

1. See, for example, Sidney Littlefield Kasfir, "African Art and Authenticity: A Text with a Shadow," *African Arts* 25 (April 1992), 2:41 – 53.

2. See Wole Soyinka, "Culture, Memory, and Development," in Ismail Serageldin and June Taboroff, eds., *Culture and Development in Africa,* Proceedings of an International Conference, interim document (Washington, D.C.: Africa Technical Department, World Bank, 1992), pp. 205 – 222.

3. See Susan Vogel, "Foreword," *Africa Explores: 20th Century African Art*, ed. Vogel assisted by Ima Ebong, with contributions by Walter E. A. van Beek, Donald John Cosentino, et al. (New York: The Center for African Art, and Munich: Prestel, 1991), p. 10 ff. Vogel's useful characterization of five major organizing "strains" is, by her own assessment, but a loose approximation. Her classifications — "traditional," "new functional," "urban," "international," and "extinct" — provide a helpful approach to a good deal of African art, but there are always works whose medium and form, content and meaning, defy neat categorization.

4. See Serageldin, "Architecture and Society," *Space for Freedom: The Search for Architectural Excellence in Muslim Societies* (Geneva: The Aga Khan Award for Architecture, and London: Butterworth Architecture, 1989), pp. 255 – 259.

5. See Bernard Rudofsky, *Architecture without Architects* (New York: Doubleday, 1964).

6. See Philip L. Ravenhill, "The Art of the Personal Object," *African Arts* 25 (January 1992), 1:70 – 75.

7. See Susan Denyer, *African Traditional Architecture* (New York: Africana Publishing Company, 1978).

8. See Jean – Jacques Guibbert, "Symbols, Signs, Signals: Walls of the City," in *Reading the Contemporary African City,* proceedings of Seminar Seven in the series "Architectural Transformations in the Islamic World," held in Dakar, Senegal, 2 – 5 November 1982 (Geneva: The Aga Khan Award for Architecture, 1983), pp. 75 – 84.

9. The rich African heritage has been codified in many ways. See, for example, Ali Mazrui, *The Africans: A Triple Heritage* (Boston: Little Brown and Company, 1986). Mazrui's classifications lead him to view the mechanisms of change in a particular light: see his "Development in a Multi – Cultural Context: Trends and Tensions," in Serageldin and Taboroff, eds., *Culture and Development in Africa,* pp. 129 – 138.

10. A number of scholars have traced the Western and other influences in African architecture (see, for example, Alain Sinou and Bachir Oloudé, eds., *Porto – Novo: Ville d'Afrique noire* (Marseille: Editions Parenthèses/ORSTOM, 1988), as well as the particular links of Islam to sub – Saharan architecture (see Labelle Prussin, "Islam and the Architecture of Sub – Saharan Africa," *Toward an Architecture in the Spirit of Islam* (Proceedings of Seminar One in the series "Architectural Transformations in the Islamic World," held at Aiglemont, Gouvieux, France, April 1978) (Geneva: The Aga Khan Award for Architecture, 1980), pp. 96 – 97.

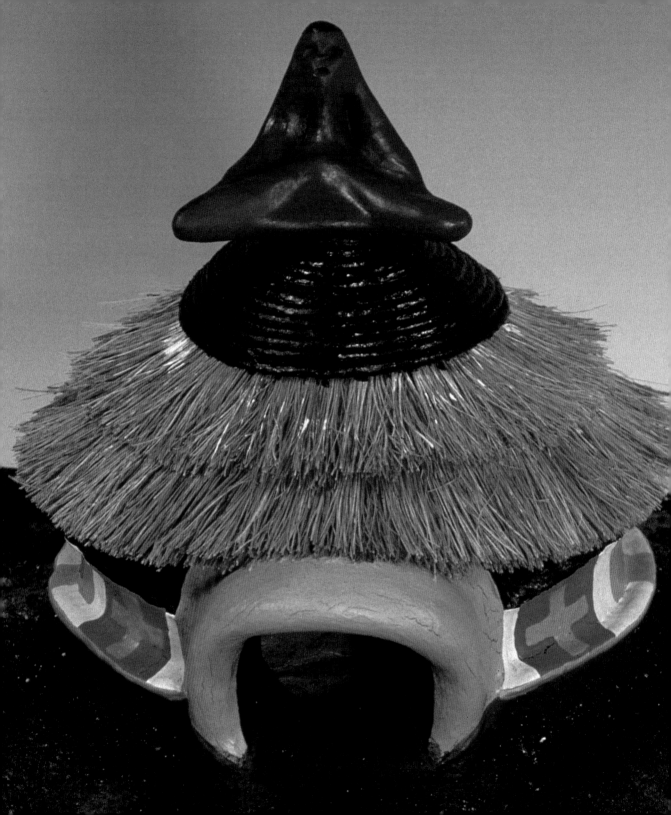

Aboudramane,
Magician of Memory

Jean-Louis Pinte

Aboudramane's vision is of Africa, an Africa as black and as embracing as a thunderstorm at night, an Africa with the colors of the day and of the darkness, an Africa whose beauty hides in the heart of its rituals, its rustling forests, its silent sleeping villages. He vibrates with this Africa, and his sculptures are an attempt to hold on to its memory. In these works, with their mysterious, energizing symbols, the attempt to reveal reality collides with the transformative imagination. As demiurge, Aboudramane creates scenes lit by the lightning flash of memory, or of a desire for the eternal. Having the unique good fortune of being able to translate his ancestral beliefs into the present, he gives them back a truth: his own.

"Wherever one is, one cannot free oneself from Africa," Aboudramane asserts; "not from its fetishes, not from its sorcerer's spirit, even less from its incantatory magic. These things impose their forms on objects, as the sun rising over the savanna prints a rhythm on the dawning day. Nature captures our emotions."

Nature has always fascinated Aboudramane, but it was stolen

from him early on — he was a city child. It took a train trip — one of those initiatory passages — to give him the fleeting glimpse of wild splendor that has always stayed in his memory. The villages he saw lifted his spirits. Guardian figures re-entered his life — his grandfather, a diviner and healer and dispenser of well-being; his father, a drummer.

Aboudramane feels that his roots are in that still-inaccessible green paradise, which he imagines rather than explores. He lets himself be inspired by the smell of the earth and by its redness daubed on the houses, by the sounds of animals in the nearby forest, by the crying of babies, the hacking of a blade against a tree. He knows that in the villages time flows as it has for centuries. When night lets go of the day, women begin to pound millet, the sun rises from the mists, and the houses seem to emerge whole from the earth, or from the shadows.

It is that feeling, that delicate moment when everything is in balance between one world and another, that Aboudramane wants to capture in his art, "*sculptures-mémoires*" of a time that he cannot allow to disappear. Imagination provokes reality. His works retain life only in its essence, alive because they are inhabited by ghosts. "I have always refused to find out what is behind the door of a house," he confesses. Innocence is left intact — out of the question to break the taboos.

Aboudramane was not born an artist, he has become one. When he first went to Paris, at the age of twenty-two, it was to work as a cabinetmaker. A chance encounter changed his life: he took a job in the studio of the Swedish painter Gosta Claesson, who remarked upon the agility of his hands and made him aware of his creative powers. Naturally the village rose up in Aboudramane's memory. He created a house out of secondhand things — matches, boxes, earth, feathers. "Why was this the image that pushed itself forward first? I have no idea," he says. "Perhaps I wanted to capture the silence of the village

when everyone's at work."

Settled in Paris, Aboudramane discovered art and artists, first Joseph Cornell, then Alexander Calder, and above all Jean Tinguely, his mirror. He knew immediately that he and Tinguely spoke the same tongue: "We see our destiny in the eyes of others." His own destiny was determined. His memory, frozen until that moment, opened up to life, to art. "I feel I'm the interpreter of what other people have forgotten," he says. "I try to capture an Africa whose forests and culture are being destroyed . . . an Africa in the process of disappearing."

Last witness of a land where people have always known the power of telluric forces, Aboudramane takes the role of magician of the earth, and captures the ephemeral lightness of time passing.

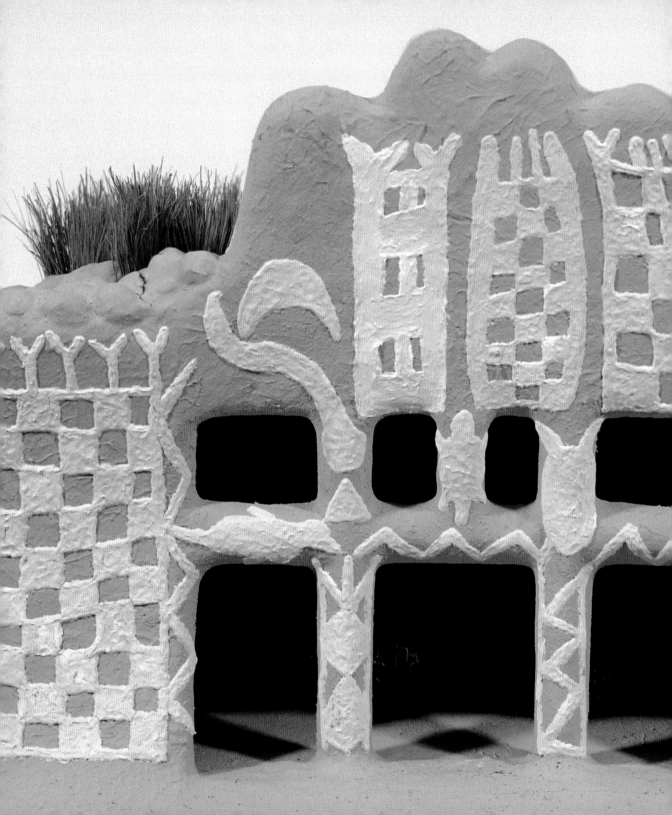

My Roots Are in Art:
An Interview with Aboudramane

Jean-Louis Pinte

Jean-Louis Pinte: All your works are titled *"Sculpture-Mémoire."* Why that name?

Aboudramane: The word "memory" is quite explicit: it suggests that ensembles of realistic or symbolic elements give rise to the creation of places or objects that are simultaneously imaginary and true. These works reflect an Africa desiring to bear witness to something on the point of disappearance.

JLP: From what processes do your works evolve?

A: I barely draw at all. My works often come to me in my sleep, or in daydreams, and also while I'm working. One piece leads to another.

JLP: Do you feel that you are influenced by any African architecture in particular?

A: There's really no such thing as African architecture, not, at least, in the cities. The villages in the bush, or near the forest, are much more interesting. Even there, though, one cannot speak of architecture as such, because there is no urbanization. The construction of a house depends on the environment. Nature dictates the form and the site.

JLP: Do your "*Sculptures-Mémoires*" express the spirit of such places?

A: The artist's job is not to reproduce but to create. Sometimes one feels humbled by what everyday life "imagines" on its own: why, say, does a mask hang on the facade of a particular house? This type of observation makes one want to be daring oneself. One is afraid, of course, of not achieving that kind of spontaneity. The important thing for an artist is to recapture the original gesture, so that the viewer of his artwork will in turn ask the same question: what is the significance of this gesture, this form, this sign?

JLP: Your works are full of signs. What do they represent?

A: It's very mysterious; I don't know myself. They very often arrive on the works' bases. They are vitally necessary. I try to express what I don't understand.

JLP: At the same time, your works emanate silence.

A: Silence is very important. The villages are often deserted, and there's little to tell whether anyone is at home in the huts or houses. It's the occult forces that live in them that matter. I refuse to open the door, to say what I see. I let the dream trace life.

JLP: How do you think a black American might look at your work?

A: If he's looking for his distant origins, it can help him place himself a little better. He can also think about what he has lost, and what that loss constitutes.

JLP: You work in France. Do you need to visit Africa for inspiration?

A: I couldn't live in Africa. When I go back there it's only for a few weeks. If I want to, I can find Africa in Paris. It's easy — there is a community where some celebration is always going on if one looks for it. And here in Paris I have the status of "artist," while in Africa I would only be a workman like everybody else — just a workman who works with materials. The idea of "art" is alien there.

JLP: Then where is your culture?

A: I'm an African still searching for his roots. I haven't lived as my ancestors did. There are still many things that I want to learn through the things I make. I need to know myself better, to educate myself. In France I look at the world differently. In Africa I was confronted by ignorance, a stranger to everything around me.

JLP: You are self-educated. Is that an advantage or a handicap?

A: An advantage! It gives me a spontaneity, I think, that I would have spent a long time recovering if I'd studied art formally. I don't overplan my work, and nothing stops me—no codes, no conventions. I am natural naturally.

JLP: What satisfaction do you get from your status as an artist?

A: It has opened me to beauty. I know how to look, touch, feel. Before it was just instinctive.

JLP: From now on, what are your roots?

A: Art — the only way to make oneself understood. And through art I try to understand Africa and myself.

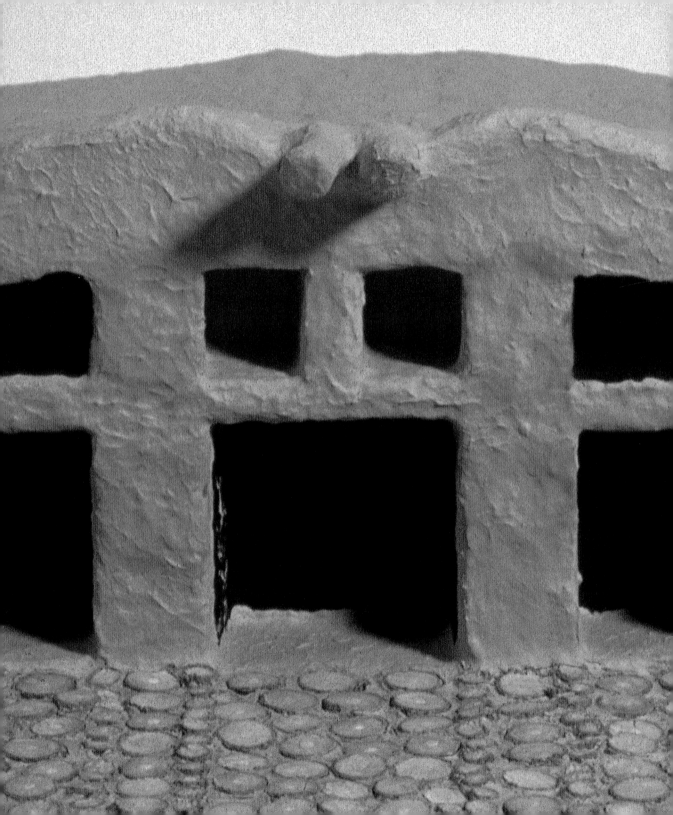

Catalogue: Aboudramane

David Frankel

La Grande Mosquée
(The great mosque), 1991
mixed media with wood, straw
36 x 42 x 39 cm.

The clay-and-beam mosques of sub-Saharan West Africa lift grandly above the low-built towns surrounding them. Though their towers go untopped by tufted coiffures of straw, in every other respect they are easily as complex and imaginative as Aboudramane's version, so that this fantastic sculpture is in fact one of the artist's more realistic creations. Inside, a wall is painted with a small praying figure, and the ceiling gets a fresco spiral (see p. 14).

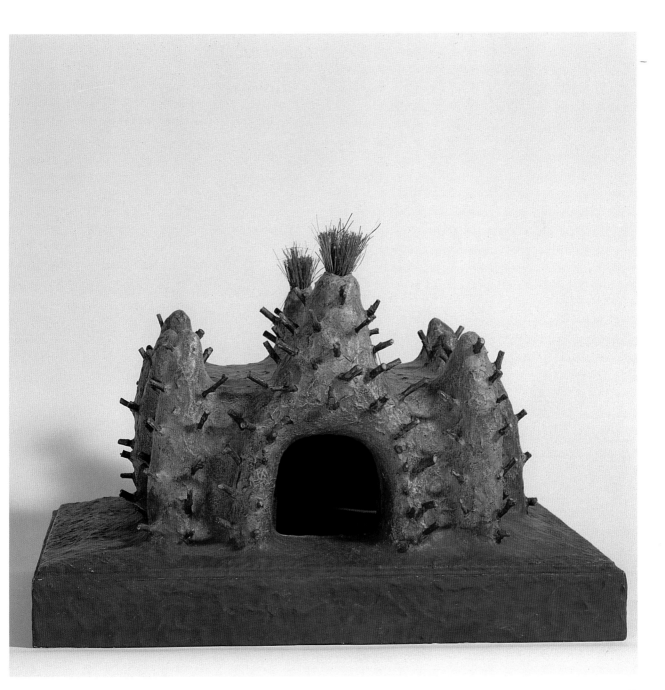

La Mosquée
(The mosque), 1989
mixed media with wood
22 x 37 x 37 cm.

This mosque, of a daintier type than *La Grande Mosquée,* contributes to a continuing strain in Aboudramane's work: an intimation of other worlds and dimensions, of hidden powers, sometimes forcefully present, as in the more recent sculptures of sorcery sites, sometimes delicate and mysterious, as in this sacred space, which conveys religion and faith through the grace of proportions, materials, and form. This desire for the magical and the holy seems poignant in Aboudramane, an immigrant or exile in a large, relentlessly secular Western city that epitomizes modernity.

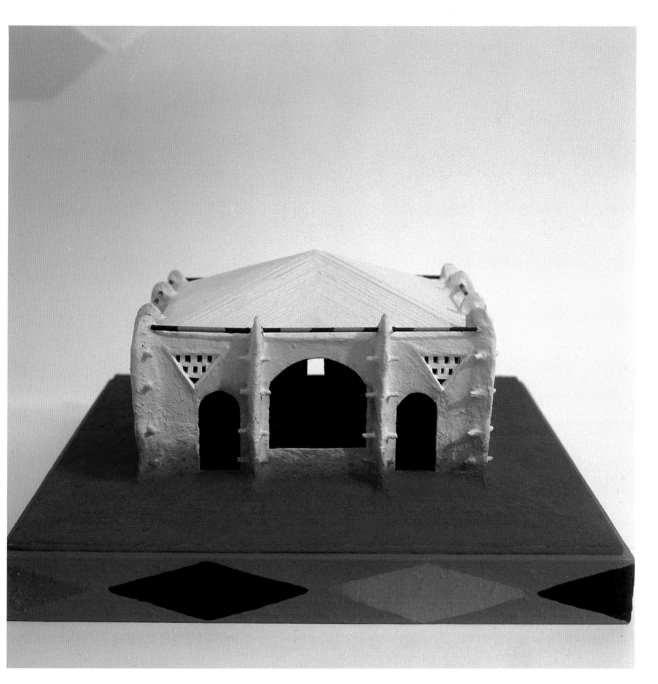

41

Le Porteur
(The bearer), 1991
mixed media with straw
36 x 43 x 25 cm.

Like the supernatural supplements to
La Maison du diable and *Le Hangar du
sorcier*, the meditating figure on the
roof of this quirky little house, and
the brightly painted symbols on its
walls, transform it into something
other than a building one could meet
in ordinary travels. It is as if
Aboudramane were trying to make a
European audience understand the
power that simple forms of traditional
architecture have in his memory —
and, indeed, in themselves.

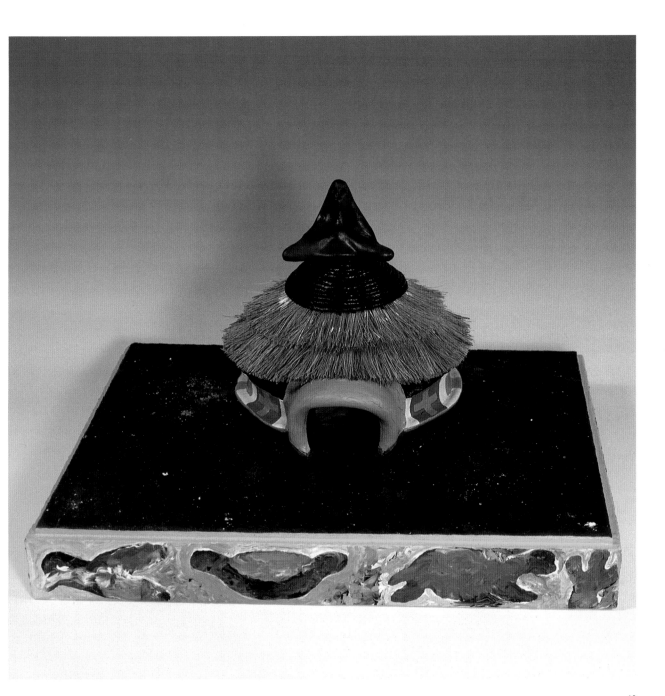

La Case sacrée
(The sacred house), 1990
mixed media
16 x 44 x 37 cm.

Aboudramane's sources often seem as much corporeal as architectural: the undulating roof of this trim clay structure evokes a curved brow sheltering windows that are clearly a pair of eyes. As in *La Maison du diable*, house becomes head — body and mind. The function of this "sacred" building is unspecified, but any small visitor approaching over the cobbles would surely sense scrutiny from an alternate world.

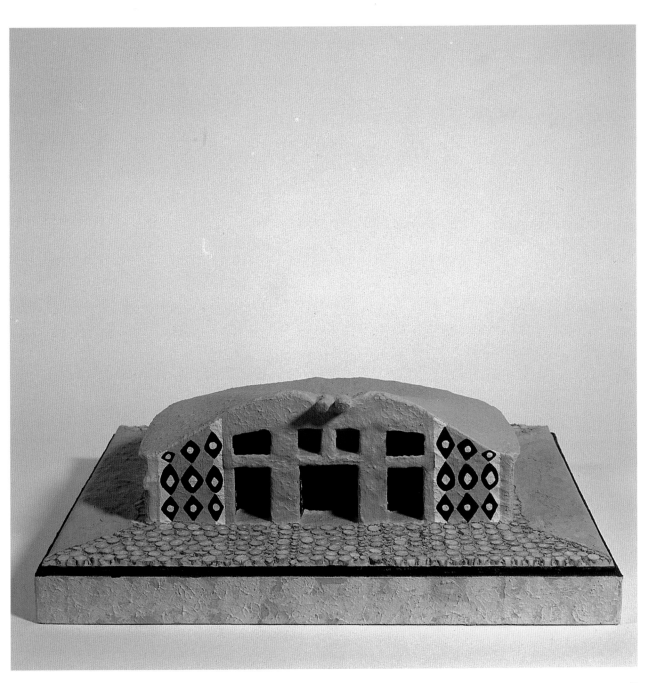

45

La Case camouflée
(Camouflaged house), 1993
mixed media with straw
28 x 43 x 36 cm.

The empty and nearly invisible interior of this structure has almost as much presence as the visible exterior. The dark areas created by open doorways and pierced walls are not just part of the surface pattern of the work, but open invitations to enter. We sense the high volume of the dark cool space expanding behind the painted facade.

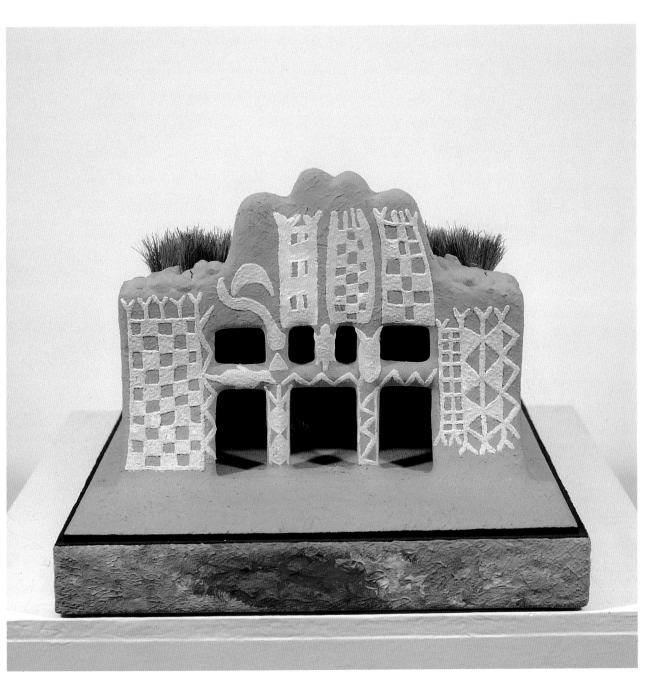

La Maison du diable
(The devil's house), 1992
mixed media with horns
43 x 36 x 34 cm.

La Maison du diable is one of a group of recent works exploring specifically magical environments. The horned-helmet reference seems incidental: by the simple addition of horns, this house becomes a whole head, a malevolent consciousness.

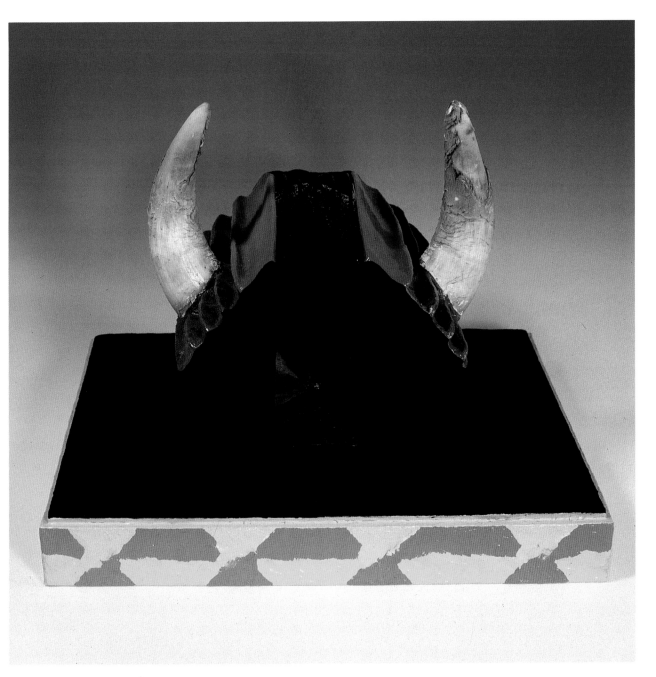

La Maison de la femme du roi
(House of the king's wife), 1990
mixed media with straw
20 x 44 x 37 cm.

Warmth, shelter, nurture: it is in the nature of these worldwide associations with the ideal concept "house," and of these practical expectations of housing, that they should translate on a deep level into feelings about the relationship of the self to the shielding human body. Accentuating the breastlike shape of a traditional African building form, Aboudramane simply makes that translation literal.

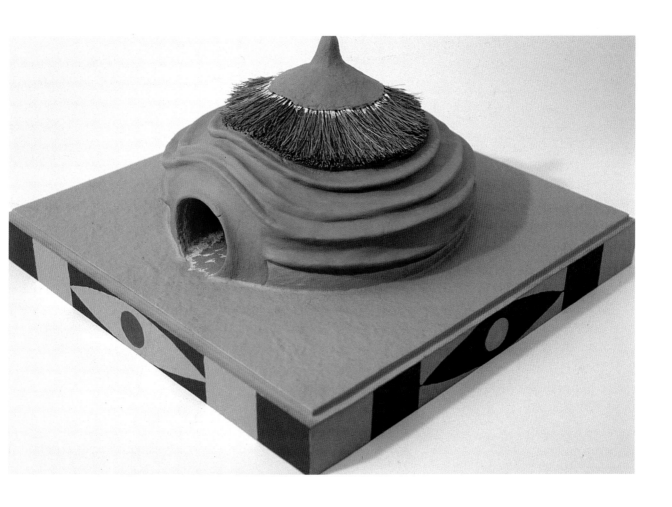

Le Hangar du sorcier
(The sorcerer's shed), 1992
mixed media with wood, straw
28 x 43 x 36 cm.

Who would dare steal cattle or stores
from this triangular outbuilding, its
slotlike open wall penetrated by an
outsize shank of wood and straw
painted with occult signs.

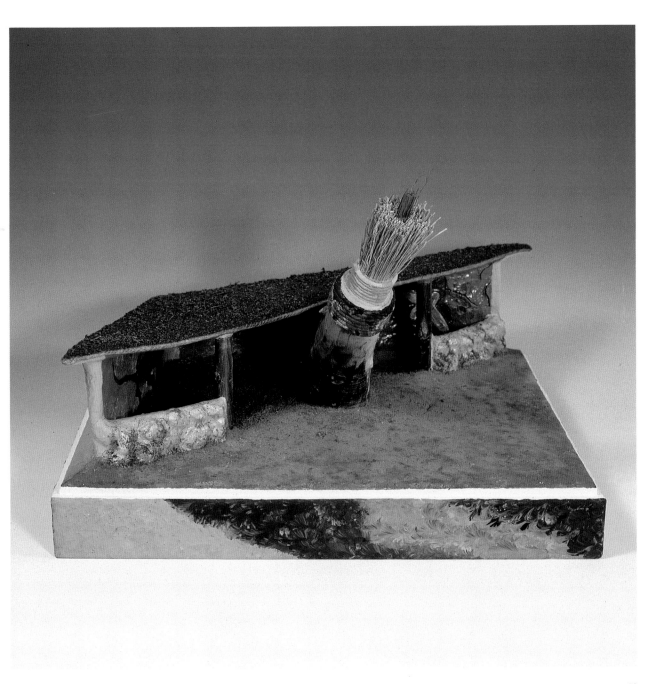

La Maison reliquaire
(The reliquary house), 1992
mixed media with wood, straw, horn
43 x 36 x 43 cm.

Like Kingelez's various disobediences of gravity, the horned crotch of wood that seems to form the center pole of Aboudramane's reliquary house is architecturally unbelievable — impossibly out of scale. Even tabletop size, the artist's talismanic construction principles are powerfully uncanny and protective.

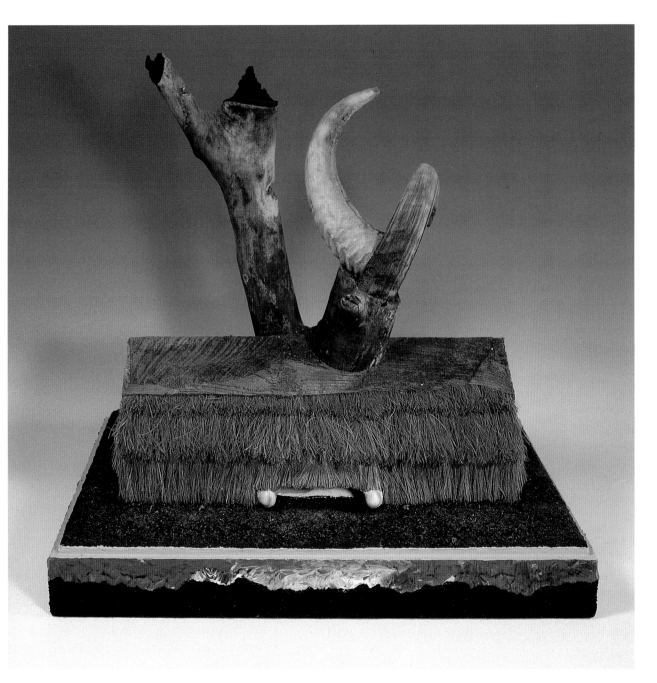

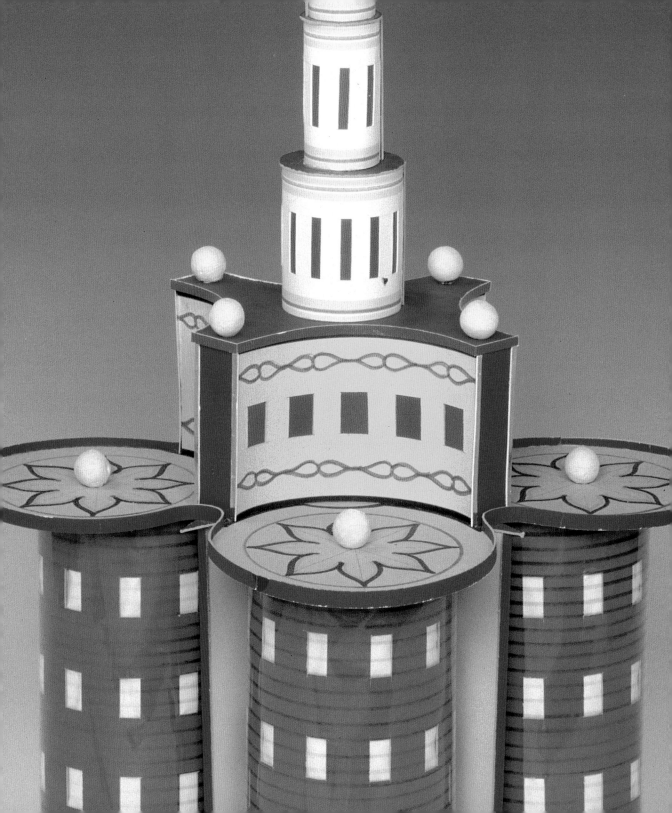

Bodys Isek Kingelez — "Extreme Maquettes"

Jean-Marc Patras

For a Westerner, even brief immersions in the company of Bodys Isek Kingelez can seem almost dreamlike: the images telescope, the arguments are brilliant but their codes are near secret, the delivery is rapid and its twists and turns are constantly opening on unsuspected landscapes. The work, meanwhile, is eloquent enough on its own. Kingelez has cleverly removed himself from the artistic syncretism practiced by the Kinshasa art world — a fine creative alloy of postcolonial academicism, bleached-out "primitive" art, and such — by proposing an investigation of modernism that yet, is not unreasonably encumbered by a desire for revenge on the whites. His approach, which is above all esthetic, sets Kingelez a little apart from his popular-art colleagues in Zaire.

I discovered Kingelez's work in "*Magiciens de la terre*," the large exhibition of global art held at the Centre Pompidou, Paris, in 1989. Kingelez's compatriot Cheri Samba, whose work was also in the show, was staying with me at the time, and Bodys often visited us. I was happy to receive him as a friend. One night he came to see me carrying a

magnificent, fragile maquette that he said he had made for me to buy, which I did. A few days later, without my having asked, he brought another, then several more. This was how, thanks to his tenacity, I was gradually led into working with him.

His work had puzzled me at first; as a form, the architectural maquette was strange to me, and seemed difficult to market. But little by little it won me over, as I began to see its contemporaneity and unfettered "Africanness." There was also a sort of defiance in it, which I liked. One of the first pieces I owned, *Stars Palms Bouygues*, is a grand upside-down pyramid; Kingelez made it to challenge the French architect Francis Bouygues to build a real building like it. Despite many appeals, he never succeeded in persuading Bouygues to take up his dare.

Even before I got to know Kingelez's work, his conversation fascinated me: ascending in breathy spirals, yet thoughtful and orderly, it seemed both ecstatic and distilled, concentrated. I felt I couldn't grasp its meaning. During later trips to Kinshasa I always visited Kingelez, and bit by bit, by listening for hours, I penetrated his world, his logic, his thought. Then I realized that his speech was like his work—rich, marvelously articulated, but like architecture in that it could provide the appearance of familiarity to a person who knew nothing of its technique. To understand it fully, I had to relearn words, phrases, forms.

First I had to admit that none of the guidelines so graciously offered me by my own culture were useful at all. I also had to see that this was work that emerged first from deep thought, then from desire; in no way did it result from frustration. Kingelez is not an architect and does not wish to be considered one. He is surprised when you ask him if he wants to see his works actually built.

In the early 1980s Kingelez was hired by Frère Cornet, then the director of the Musée National in Kinshasa, to take a job in the mask-

restoration department. There he could put his talent to work, and for the first time had materials available with which he could begin to make his maquettes. His proximity to the antiquities he was restoring, I think — objects so admired by Westerners — stirred him, challenged him, to create strong modern art that at some point white people would have to recognize. Why were they only concerned with objects that were ancient to the point of deterioration? Why couldn't they be interested in contemporary African art? Such questions, I believe, lie at the heart of Kingelez's work. He and other popular artists of Kinshasa want to spearhead a free artistic movement opposed to the meaninglessness of academic art; they also want to separate themselves from their culture's past, which to their minds is too powerful a presence in the rest of the world's image of Africa.

Seemingly unconsciously, Kingelez registers everything in reach and without apparent analysis re-creates it all as his own world. His constructions aren't put together as rationally as they appear to be: there are no preparatory sketches, no notes. Each maquette is first of all the expression of an imperious urgency to find an esthetic solution for a real or imagined given: a celebration of a person (*La Mitteranéenne*, for Mitterand), a response of the African spirit to the whites (*Stars Palme Bouygues*), a reaction to a monument (*Bel Atlas/Grande Arche de la Défense à Paris*), a materialization of a world event (*La Moscovite*), a proposal for a real building (*Hôpital pour le Sida*), and so on. Each maquette is a counterproposition to an object or event already in existence, or a reply to a need for one, and it is for this among other reasons that his work appears simultaneously unreal and coherent.

It has been written that the only real architectural "spectacles" Kingelez could have seen before visiting Europe were a few buildings on Kinshasa's Avenue 24 Juin, which is the local Champs Élysées. This idea

reflects a reductive, underdeveloped view of his work and personality. Today, Kingelez travels all over the world, but I don't think these expeditions will have much influence on his art: even before taking a plane for the first time, he had traveled considerably. His journeys are in his head. To have seen him spend hours in the modest armchair in the courtyard of his little place in Kinshasa, and to listen to him speak, is to understand that a simple photo in an old European magazine is enough to set him off elaborating a story, which becomes a personal account of the experience, and from there the beginning of an intuitive creative process. The story will be built in the hand's guiding of the razor blade, cutting the cardboard, which — colored, decorated, one part stuck to another — will become reality.

Each maquette springs from an interior monologue that is born and evolves in the artist's head. Should you chance to be in the vicinity when that conversation nears its end, you will hear an oral expression the style of which will be the only abstract prefiguration of what the work will be. Once the problems of dealing with the materials are solved, and the groans that accompany their solution die away (these groans are an integral part of the creative process), the story/maquette will have created itself without apparent preparation, the hand and its tools writing a story.

Kingelez speaks of the "*maquettes extrêmes*," the extreme or final maquettes, and he is right: each maquette is the final outcome of Kingelez's solitary discourse, his internal conversation. Each maquette is a solution. It is in this perspective, I believe, that Kingelez's work takes on its full amplitude. This is critical art: it wants to cut itself off from the past, or at any rate from the phantasmagoric, unchanging Africa that has for many years been the fiction of modern sculpture in the West. With the work of other Kinshasa artists, it is a response to the

homogenization of African expression effected in the West for Westerners, accepted by them as authentic, and exhibited by them because it is aseptic and unthreatening. Kingelez says that his work "carries within it the sacrifice that offers the hope of a better future, of a better life, the good life."[1] It speaks of his desire to demonstrate his own importance, and the depth of his culture and of his way of seeing the objects and events of his city and of the world. One's first impression of one of Kingelez's maquettes is only a beginning; what it conceals is not buried or hidden, but one must want to understand it, and be ready to adapt to its language.

Kingelez's work offers us an opportunity to look at Africa through iconoclastic eyes. It sets the fantasies Westerners and Africans have about each other back to back. Africa and the West have been keeping company only a hundred years — not a long time. For the past hundred years the one group believed it could master everything, and the other had the sense to stand back and let it try. A hundred years later, each finds itself back where it began, but on a field of ruins — the one group guilty, the other slowly pulling itself together.

Meanwhile new spirits are opening up, the global village is building its foundation. Artists like Kingelez are the visionaries of a decoded future where the questions that are asked call for new grids for reading. The game is passionately engrossing — like cutting up cardboard with a razor, and creating a dream in three dimensions.

1. Quotations of Body Isek Kingelez from *Magiciens de la terre*, Paris: Editions du Centre Pompidou, 1989.

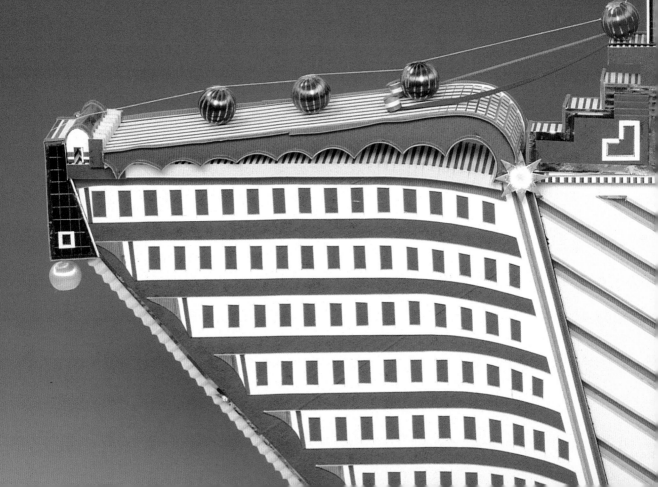

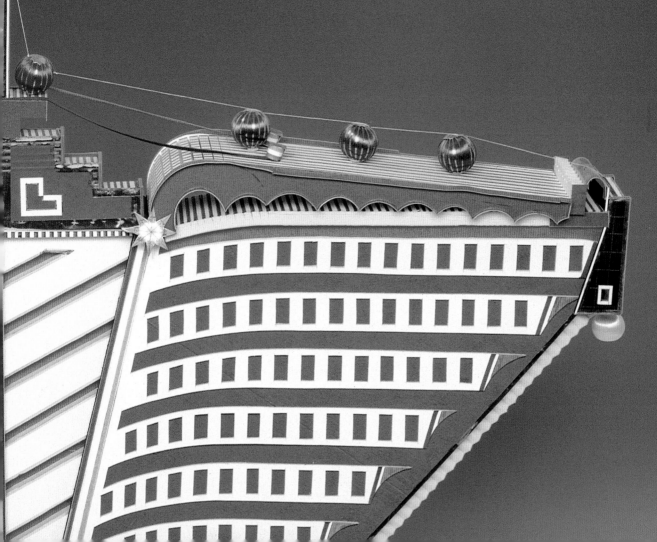

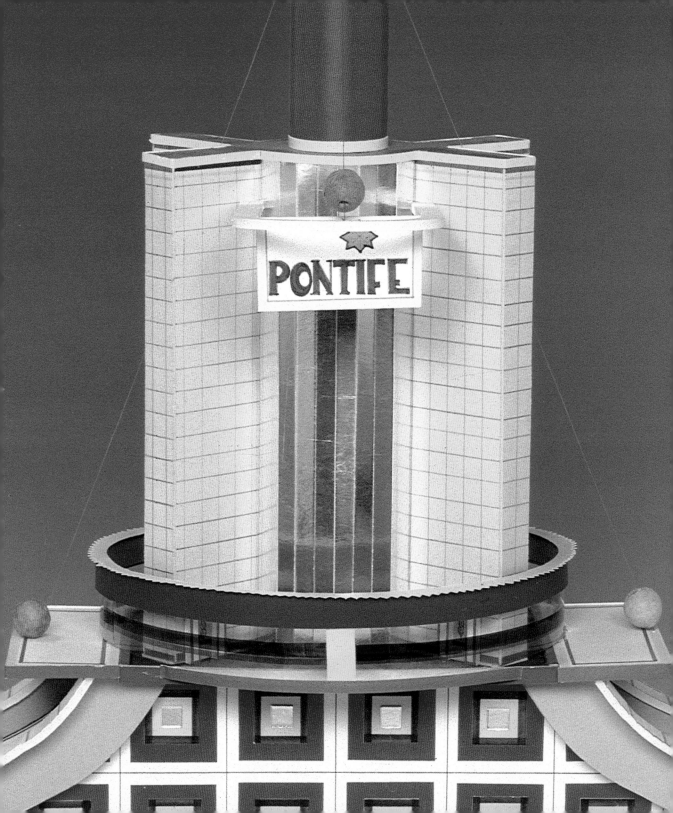

Catalogue: Bodys Isek Kingelez

David Frankel

Kinshasa Label
1989
mixed media
90 x 49 x 69.5 cm.

If Aboudramane's sculptures suggest a past that never quite was, informed as they are by fantasy, memory, geographic and temporal distance, and a subliminal sense of the divide forced by engulfing change, Kingelez's works are informed by a vision of a future that never quite will be. Here, circular flat roofs look like the helicopter landing pads that American magazines of the '50s imagined for every office building in the city of tomorrow; the immensely tall spire with its sunlike seal—*Kinshasa Label*, a pun on "Kinshasa *la belle*"—would be a beacon of modernist promise realized, Kinshasa's Empire State Building. Yet in Kingelez's hands it is only thirty-two inches high.

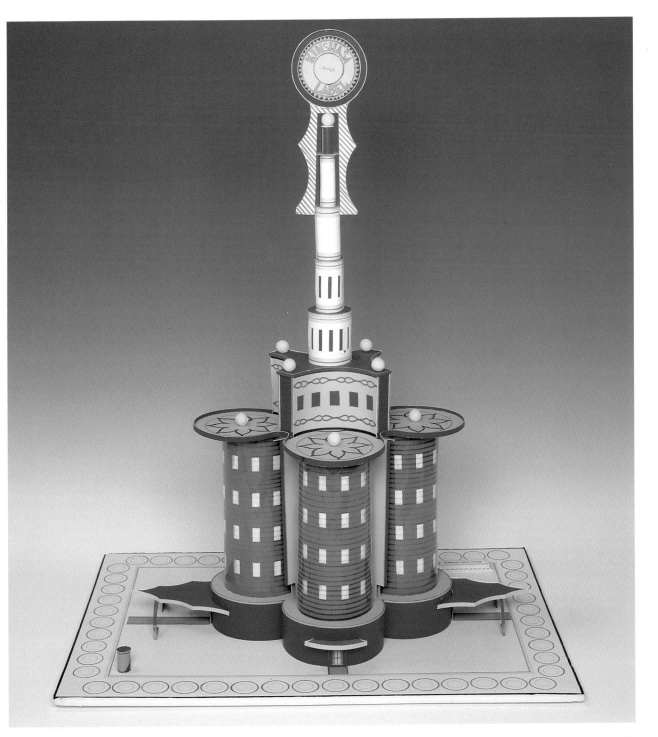

Bel Atlas/Grande Arche de la Défense à Paris
(Handsome Atlas/Great arch of la Défense in Paris), 1989
paper, cardboard, mixed media
85 x 66 x 44 cm.

Atlas was the giant who bore the heavens on his shoulders in Greek myth. Perhaps the new arch of la Défense in Paris — a vast unornamented open square, like a modernist picture frame around sky — seemed to Kingelez a modern candidate for that role. But he filled his own square arch with something resembling a Soviet university, down to the hammer-and-sickle-like logo.

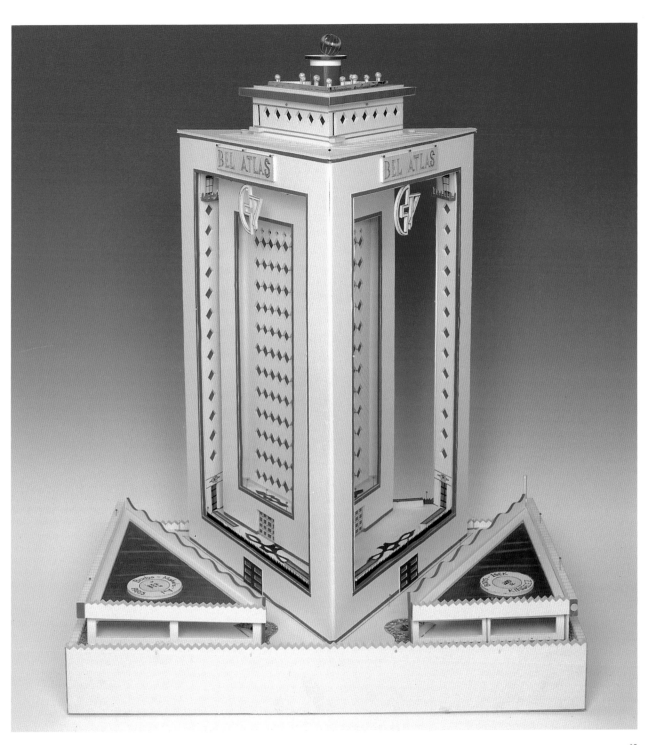

Pontife
(Pontiff), 1990
mixed media
82 x 62 x 50 cm.

The hippy curves of *Pontife* are far more luxurious than the facades of most full-scale rounded buildings, such as, say, Morris Lapidus's Fontainebleau hotel in Miami. Kingelez's maquettes work to heighten the viewer's awareness of architecture as modeled sculptural form rather than immutable fact. At the same time, they are slyly humorous: is this work a homage to the Pope, or is the sensuousness of *Pontife* a gentle joke on His Holiness?

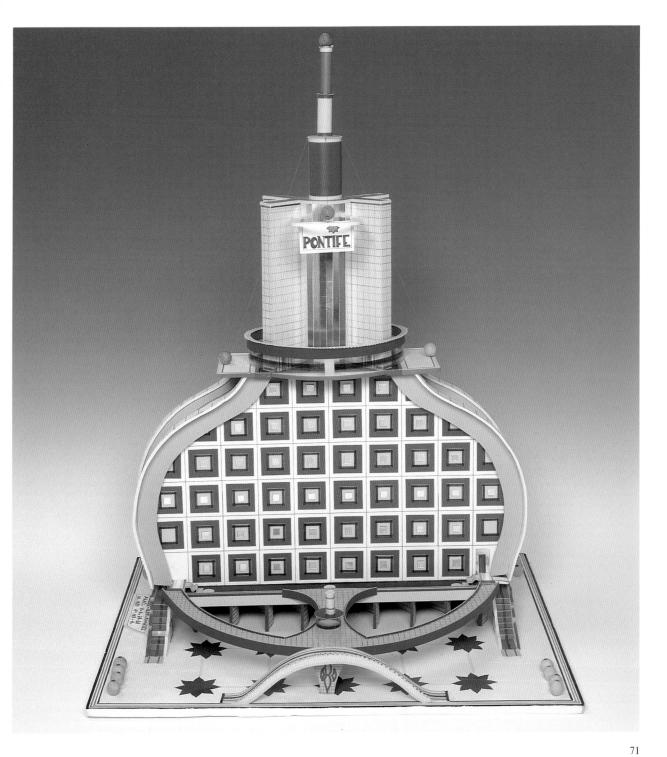

Stars Palme Bouygues
(Stars Palm Bouygues), 1989
paper, cardboard, mixed media
100 x 40 x 40 cm.

The structures for which Kingelez's sculptures might be maquettes are often unrealizable by any technology but the artist's. This one reverses architecture's rules of distributing weight, geometrically upping the ante with every increasingly top-heavy story. *Stars Palme Bouygues* was conceived as a construction challenge for the important French builder Francis Bouygues, who prudently ignored it.

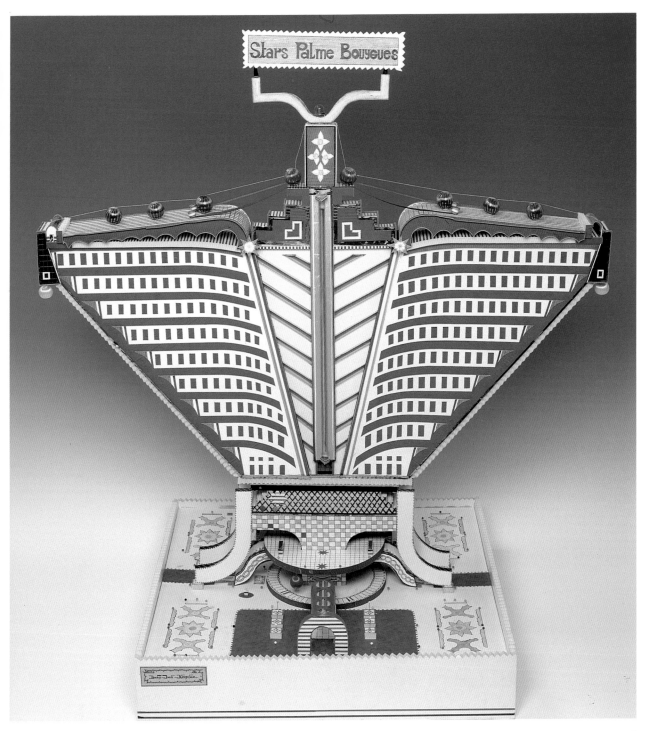

Artist's Biographies

ABOUDRAMANE

1961	Born in the city of Abidjan, Côte d'Ivoire
1975 –1984	Works as a cabinetmaker and sculpts in wood
1984	Travels to Italy
1986 – 1987	Takes two trips to France
1988	Moves to Paris and works on sculptures

Group Exhibitions

1990 June	*"Trois Génies à la Bastille"* Exhibition of three artists, Paris
1991 Oct.	*Art Session '91* 40 artists at the Espace Glauser, Paris
1992 Jan. – Feb.	"Other Drums, Visionary Works" Cavin-Morris Gallery, New York
1992 Apr. – May	*"Paysages"* Galerie Gloria Cohen, Paris

1992 Sept. – Oct. *"Parcours privés '92"*
Les Affaires Culturelles de la Ville de Paris, Jardin de l' Hôtel de Sully

1992 Dec. *"Miroirs Miroirs"*
Two artists at the Galerie Les Alizes, Brussels

Solo Exhibitions

1991 Oct. *"Murs - Murs de Terre"*
Galerie Maine Durieu, Paris

1992 Aug. Espace Béchard, L'Isle-sur-la-Sorgue, France

1993 Feb. *"Découvertes"*
Galerie Praz-Delavallade, Grand Palais, Paris

1993 June Galerie Praz-Delavallade, Paris

BODYS ISEK KINGELEZ

1948 Born in the town of Kimbenbele-Ihunga, Zaire

1980s Works as a restorer in the Musée National, Kinshasa.
 Makes the first of his *"extrême-maquettes,"* which
 total over 300 to date

Group Exhibitions

1989 *"Magiciens de la Terre"*
 Centre G. Pompidou/Grande Halle de la Villette,
 Paris

1990 F.I.A.C.
 Jean-Marc Patras Galerie, Paris

1991–1992 *"Africa Hoy"*
 Centro Atlantico de Arte Moderno, Las Palmas de
 Gran Canaria (Sept. – Nov. 1991), Groningen
 Museum, Groningen, Holland (Dec. 1991 – Feb.
 1992), Centro Cultural de Arte Contemporáneo,
 Mexico D.F. (Feb. – Jun. 1992)

 "Out of Africa"
 Saatchi Foundation, London

1992 Art Cologne, Germany
 Jean-Marc Patras Galerie

Solo Exhibitions

1991 Jean-Marc Patras Galerie, Paris, France

1992 *"Bodys Isek Kingelez - Architekturvisionen aus Zaire"*
 Haus der Kulturen der Welt, Berlin, Germany

Aboudramane:
Un Magicien de la Mémoire

Jean-Louis Pinte

Dans son regard il y a l'Afrique. Une Afrique noire et caressante comme un soir d'orage. Une Afrique aux couleurs de soleil et de nuit, dont la beauté se cache au coeur de ses rites, des forêts frémissantes et du silence des villages endormis. Aboudramane vibre de cette Afrique-là dont il tente de retenir dans des compositions sculpturales la mémoire. Des oeuvres chargées de symboles, mystérieuses ou la tentation de découvrir la réalité se heurte à la barrière de l'imaginaire. Démiurge, il recrée des lieux traversés par la fulgurance d'un souvenir ou d'un désir d'éternité. Avec l'unique bonheur de traduire des croyances ancestrales. D'en restituer une vérité. La sienne.

"Où que l'on soit on ne peut pas se libérer de l'Afrique," avoue t'il, "ni de ses fétiches, ni de son esprit sorcier encore moins de sa magie incantatoire. Ils imposent aux objets leur forme, comme l'aube qui se leve sur la savane imprime un rythme à la journée qui commence. La nature capte nos émotions."

Cette nature a toujours fasciné Aboudramane. Enfant de la ville, elle lui a été volée. Il lui faudra un voyage en train, un de ces trajets initiatiques, pour qu'il puisse d'un regard fugace en retenir la sauvage splendeur.

Les villages aperçus l'exaltent. Des figures tutélaires surgissent, son grand-père féticheur, dispensateur de bien, et son père batteur. Aboudramane sent que ses racines sont là dans ce vert paradis encore inaccessible. Mais plutôt que de l'explorer il va l'imaginer. Il se laisse inspirer par l'odeur de la terre, sa couleur rouge qui maquille les maisons, les cris des fauves rodant dans la forêt toute proche, les enfants piaillant ou le martelement de la cognée sur un tronc d'arbre. Il sait que dans les villages le temps coule ainsi depuis des siècles. Lorsque la nuit laisse échapper le jour les femmes commencent à piler le mil, le soleil sort de la brume et les maisons semblent émerger toutes entières de la terre ou des ténèbres.

Cette émotion-là, ce frêle instant où tout bascule d'un monde à l'autre Aboudramane va vouloir les retrouver dans ses compositions, "sculptures-

mémoires" d'un temps qui ne doit pas disparaître. L'imaginaire provoque la réalité. Ses oeuvres ne retiennent que l'essence de la vie, vivantes parce que peuplées de fantômes. "J'ai toujours refusé de savoir ce qu'il y avait derrière la porte d'une maison," confesse-t-il. L'innocence est intacte. Pas question de violer des interdits. Aboudramane n'est pas né artiste, il l'est devenu.

Lorsque âgé de 22 ans il se rend à Paris c'est pour exercer le métier d'ébeniste. Mais une rencontre va bouleverser sa vie. Ce sera celle d'un peintre suédois Josta Claesson chez qui il est venu travailler. Claesson remarque l'agilité de ses mains et lui fait prendre conscience de son pouvoir de créer. Tout naturellement le village ressurgit dans sa mémoire. Il crée une maison confectionée avec des matériaux usagés, allumettes, cartons, terres, plumes ... "Pourquoi cette oeuvre s'est-elle imposée d'emblée. Je n'en sais rien" répond-il. "Je voulais peut-être retrouver ce silence qui règne dans un village lorsque ses habitants sont au travail."

En s'installant à Paris, Aboudramane découvre l'art et les artistes. En premier lieu Joseph Cornell, Calder et surtout Tinguely, son miroir. Il sait dès cet instant qu'il parle le même langage que lui. "Notre destin on le voit dans le regard des autres." Le sien s'accomplit. Sa mémoire figée jusqu'à maintenant s'ouvre à la vie. A l'art. "Je me sens l'interprête de ce que les autres ont oublié" constate-t-il. "J'essaie de capter une Afrique dont on détruit les forêts et la culture. Une Afrique en train de disparaître."

Dernier témoin d'une terre où les forces telluriques ont toujours effrayé les hommes, Aboudramane capte l'éphémère légéreté du temps qui passe. En magicien de la terre.

Interview Aboudramane
"Mes Racines c'est l'Art"

Jean-Louis Pinte

Jean-Louis Pinte: Vos compositions s'intitulent "sculpture-mémoire." Pourquoi les dénommer ainsi?

Aboudramane: Le mot mémoire est assez explicite. C'est un ensemble d'éléments réalistes ou symboliques qui débouchent sur la création de lieux ou d'objets imaginés et vrais en même temps. Ils sont le reflet d'une Afrique dans laquelle se projette le désir de témoigner sur quelque chose en train de disparaître.

JLP: De quelle réflexion naissent vos oeuvres?

A: Je ne dessine pratiquement pas. Mes oeuvres voient souvent le jour dans mon sommeil ou dans mes rêves. En travaillant aussi. Une pièce en provoque une autre.

JLP: Est-ce que vous vous sentez influencé par une certaine architecture africaine?

A: Il n'existe pas d'architecture africaine, du moins dans les villes. En revanche les villages dans la brousse ou près des forêts sont beaucoup plus intéressants. Mais là aussi on ne peut pas parler d'architecture, puisqu'il existe aucune urbanisation. La construction de maisons dépend de l'environnement. C'est la nature qui dicte la forme et le lieu.

JLP: Vos "sculptures-mémoires" s'approchent-elles de cet esprit-là?

A: Le travail de l'artiste n'est pas de reproduire, mais de créer. Parfois il se sent modeste par rapport à ce que le quotidien imagine lui-même. Pourquoi y-a-t-il un masque accroché sur le fronton d'une maison? C'est ce type d'observation qui provoque l'envie d'oser soi-même. Mais on a peur de ne pas atteindre une telle spontanéité. L'important pour l'artiste c'est de retrouver le geste primitif pour qu'à leur tour ceux qui regarderont l'une de ses oeuvres se posent la même question. Quelle est la signification de ce geste? De cette forme? De ce signe?

JLP: Justement à propos de signes vos pièces en sont chargées. Qu'est-ce qu'ils représentent?

A: C'est très mystérieux. Je ne le sais pas moi-même. Ils interviennent très souvent sur le socle. Ils ont une nécessité vitale. J'essaie d'exprimer ce que je ne comprends pas.

JLP: Vos oeuvres sont en même temps empreintes de silence.

A: Ce silence est très important. Les villages sont souvent déserts, et peu importe de savoir s'il y a quelqu'un dans les cases ou les maisons. Ce qui compte ce sont les forces occultes qui les habitent. Je refuse de pousser la porte, de dire ce que je vois. Je laisse la part du rêve tracer la vie.

JLP: A votre avis, comment un noir américain peut-il percevoir votre travail?

A.: S'il cherche ses origines lointaines ça peut l'aider à se situer un peu mieux aujourd'hui. Il peut aussi penser à ce qu'il a perdu. Ce qu'est cette perte.

J.L.P.: Vous travaillez en France. Avez-vous besoin de retourner en Afrique pour vous inspirer?

A: Je ne pourrais pas vivre en Afrique. Lorsque je m'y rends c'est pour quelques semaines seulement. L'Afrique je la trouve si je le veux à Paris. Ce n'est pas un problème. Il existe une communauté où la fête est présente si on la cherche. Ici j'ai un statut d'artiste, alors qu'en Afrique je ne serais qu'un ouvrier qui travaille des matériaux. Comme tout le monde. L'idée de l'art est étrangère.

JLP: Où est alors votre culture?

A: Je suis un africain qui cherche encore ses racines. Je n'ai pas vécu comme mes ancêtres. Il y a encore beaucoup de choses que je veux apprendre à travers ce que je fais. J'ai besoin de me connaître mieux, de m'éduquer. En France je regarde le monde différemment. En Afrique j'étais confronté à l'ignorance, étranger à tout ce qui m'entourait.

JLP: Vous êtes autodidacte. Est-ce un avantage ou un handicap?

A: Un avantage! Je pense que j'ai une spontanéité de propos que j'aurais peut-être mis beaucoup de temps à reconquérir si j'avais fait des études artistiques. Je ne calcule pas et rien ne m'arrête, ni codes, ni convention. Je suis naturel ... naturellement.

JLP: Quelle satisfaction tirez-vous de votre statut d'artiste?

A: Ça m'a ouvert à la beauté. Je sais regarder, toucher, sentir. Jusque là ce n'était qu'instinctif.

JLP: Quelles sont désormais vos racines?

A: C'est l'art, la seule manière de se faire comprendre. Et à travers l'art j'essaie de connaître l'Afrique et moi-même.

Bodys Isek Kingelez - "Maquettes Extrêmes"

Jean Marc Patras

Pour un occidental plongé par immersions successives, même brèves, dans la fréquentation de Bodys Kingelez, le voyage est une excursion onirique aux confins du délire: les images se téléscopent, la dialectique est brillante mais fait appel à des codes presques secrets, le débit du personnage est rapide et suit des méandres qui offrent à chaque détour des paysages insoupçonnables. Pourtant l'oeuvre parait d'elle-même très parlante. C'est que Kingelez s'extrait avec génie du syncrétisme artistique environnant (bon aloi créatif, académisme post colonial, blanchiment de l'art primitif etc.) en faisant une proposition ésthétique nette qui s'inscrit elle-même dans une recherche globale du modernisme sans s'encombrer outre mesure d'une revanche outrancière vis à vis des blancs. En cela Kingelez se démarque un peu de ses confrères artistes populaires de Kinshasa car sa démarche est avant tout esthétique.

J'ai decouvert le travail de Bodys Kingelez dans l'exposition presentée par Beaubourg *Magiciens de la terre* en 1989. A l'époque j'hébergeais son compatriote Chéri Samba qui exposait lui aussi à Beaubourg et Bodys lui rendait de fréquentes visite; je me contentai de le recevoir comme un ami. Un soir il arriva chez moi encombré d'une fragile et magnifique maquette qu'il me dit avoir réalisé afin que je lui achète; ce que je fis. Quelques jours plus tard sans que je n'ai le moins du monde passé commande il m'apporta ainsi une, puis plusieurs maquettes. C'est ainsi que grâce à sa ténacité je fus amené à travailler avec lui.

Dès le début son travail m'avait plongé dans une assez grande perplexité car le médium (la maquette) m'etait étranger et me semblait difficile à commercialiser. Cependant je me laissais gagner petit à petit par la magie de ce travail où je trouvais sans savoir pourquoi une Africanité décalée et une grande modernité. Il y avait dans ses oeuvres une sorte de défi qui me plaisait et qui m'avait aussi séduit chez Samba. D'ailleurs une des premières maquettes que j'eus entre les mains s'intitulait *Stars Palmes Bouygues* et figurait une magnifique pyramide à l'envers. En la construisant Bodys comptait défier Bouygues de construire "en vrai" un tel bâtiment. Malgré ses appels

incessants, il ne réussit pas à convaincre l'entrepreneur de relever le défi.

Avant même l'oeuvre, c'est le discours de Kingelez qui m'a tout de suite fasciné: construit en spirale ascendante, plein de souffle, réfléchi et ordonné il m'apparut délirant et alambiqué, je me sentais incapable d'en saisir le sens. Plus tard, au cours de mes séjours à Kinshasa je ne manquais jamais de rendre visite à Bodys, et petit à petit, en l'écoutant attentivement pendant des heures, je pénétrais dans son monde, dans sa logique, dans sa dialectique. Alors je me rendis compte que son discours était comme son oeuvre, riche, merveilleusement articulé, mais que, semblable à l'architecture qui nous apparait comme une discipline familière sans que nous en connaissions la technique, il fallait que je réapprenne les mots, les phrases et les formes.

Il fallait d'abord admettre qu'aucun des repères si gracieusement offert par ma propre culture n'était de quelque utilité; il fallait en même temps admettre que cette oeuvre en etait une, qu'elle procédait d'abord d'une réflexion, puis d'un désir. En aucune manière il ne s'agit d'une frustration: Kingelez n'est pas, ne veut pas être considéré comme un architecte et de voir ses oeuvres construites en dur est le cadet de ses soucis. La question lui fut posée et elle suscite toujours chez lui une surprise.

Au début des années 80, Bodys avait été engagé par le Frère Cornet (alors directeur de l'institut des musées du Zaïre), au département de restauration de masques du musée National de Kinshasa. Là il put mettre à contribution sa dextérité, et ayant à sa disposition le matériel qui lui manquait auparavant, il put commencer à créer ses premières maquettes. Je pense que la fréquentation assidue des "vieilleries" qu'il restaurait et pour lesquelles les blancs ont tant d'admiration, l'ont incitées par défi à créer lui même une oeuvre moderne et forte que devrait, à un moment ou à un autre, s'imposer à eux. Pourquoi donc les blancs s'inquiétaient-ils uniquement d'oeuvres aussi anciennes et à ce point détériorées et pourquoi ne pouvaient'ils pas s'intéresser à la création contemporaine issue de génie Africain? Il y a là, je crois, l'essence du travail de Bodys. Chez Bodys Isek Kingelez, et les autres artistes populaires de Kinshasa, est présent le désir d'être le fer de lance d'une création artistique libre, en opposition à un art académique vide de sens, et la volonté de se démarquer d'un passé culturel, qui à leur gré, est trop présent dans l'idée que le reste du monde se fait de L'Afrique.

Kingelez capte d'une manière inconsciente, tout ce qui passe à sa portée et recrée sans analyse apparente un monde qui lui est propre. Son travail ne s'élabore pas de façon rationelle comme pourrait le laisser croire l'observation de son oeuvre: aucun croquis préparatoire, aucune note précise, n'alimente sa création. Chaque maquette est

d'abord l'expression du besoin impérieux de proposer une solution esthétique à une donnée fictive ou réelle: célébration d'un personnage (*La Mittéranéenne*) réponse du génie Africain au génie blanc (*Stars Palme Bouygues*), réponse à un monument (*Bel Atlas/Grande Arche de la Défense à Paris*), matérialisation d'un évènement mondial (*La Moscovite*), proposition pour un bâtiment fonctionnel (*Hopital pour le Sida*) etc. Chaque maquette est une contre proposition à quelque chose de déjà éxistant ou répondant à un besoin, et c'est entre autre pourquoi elle nous apparait à la fois irréelle et cohérente.

Il a été écrit que le seul spectacle d'architecture que Kingelez ait pu contempler avant de voyager, était celui des quelques immeubles de l'avenue du 24 Juin à Kinshasa qui sont les Champs Elysées locaux. Je pense que c'est une vision réductrice et sous développée du travail de Kingelez et de sa personnalité. Avant même d'être monté dans un avion pour la première fois de sa vie Kingelez avait beaucoup, beaucoup voyagé. Je ne pense pas que le fait de courir le monde aujourd'hui aura une grande influence sur son travail. Ses voyages se passent dans sa tête. Il suffit de l'avoir vu passer des heures assis sur son modeste fauteuil dans la cour de sa parcelle à Kinshasa, et de l'écouter, pour comprendre qu'à partir d'une simple photo entrevue dans un vieux magazine européen qui sera le stimuli de départ, il va savoir élaborer une histoire, une prise de conscience personnelle de l'évènement, puis de là, entamer un processus créatif intuitif. L'histoire se construira dans la main qui guidera la lame de rasoir tranchant le carton, que collé bout à bout, colorié, décoré deviendra réalité.

Chaque maquette est le fruit d'une palabre intérieure qui prend naissance et évolue dans la tête de l'artiste; lorsque cette palabre commence à aboutir et que vous avez la chance d'être dans les parages, vous en aurez une expression orale que à elle seule, de par son style, sera la préfiguration abstraite de l'oeuvre en devenir. Une fois les problèmes matériels réglés et les gémissements qui les accompagnent tous (ils font partie intégrante du processus créatif...) l'histoire/maquette se créera d'elle même sans préparation apparente, la main écrivant une histoire à l'aide des outils.

Bodys parle de "maquettes extrêmes" et il a raison: l'extrémité finale de la palabre est la solution; acceptée par tous de façon consensuelle. Chaque maquette est l'extrêmité de la palabre solitaire de Bodys, elle même nourrie d'images distortionnées, chaque maquette est une solution. Je crois que c'est de cette façon, qu'il faut envisager le travail de Kingelez et c'est en le plaçant dans cette perspective qu'il prend toute son ampleur. L'oeuvre de Kingelez est critique, elle se veut une coupure entre le passé d'une Afrique fantasmatique et figée qui fût longtemps l'alibi de la modernité plastique en

occident. C'est la réponse (avec celles d'autres artistes de Kinshasa) à l'uniformisation d'une expression Africaine crée en occident pour les occidentaux, acceptée par eux comme authentique, montrée par eux et véhiculée par eux car non dérangeante et aseptisée. "Elle porte en elle le sacrifice qui donne l'espoir d'un avenir meilleur, l'espoir de bien vivre, de bonne vie,"dit Bodys. Elle est le porte-parole du désir de l'artiste de faire apparaître son "importance" et le fondé de sa culture, de sa façon propre d'envisager les choses et les affaires de la cité et du monde. Il ne faut pas s'arrêter à la première image laissée par une maquette de Kingelez; ce qu'elle recelle n'est pas enfouie ni caché mais il faut vouloir comprendre et s'adapter à son langage.

L'oeuvre de Kingelez nous offre une opportunité d'appréhender l'Afrique à travers un regard iconoclaste. Elle renvoi dos à dos les fantasmes des uns par rapport aux autres, Occidentaux et Africains. L'afrique et l'occident ne se fréquente que depuis 100 ans — c'est peu. En 100 ans les uns ont cru qu'ils maitrisaient tout et les autres ont eu la sagesse de laisser faire. Cent ans plus tard grâce à cette magnifique incompréhension, acte manqué splendide, chacun se retrouve à la case départ, mais sur un champ de ruine les uns culpabilisent, les autres se ressaisissent lentement.

Entre temps les esprits se sont ouverts, le Village Global culturel pose ses fondations, des artistes comme Kingelez sont les visionnaires d'un avenir décodifié ou les questions qui se posent appellent de nouvelles grilles de lecture; c'est un jeu passionant, comme de prendre une lame de rasoir, découper du carton et créer un rêve en trois dimensions.

Authors

Celeste Olalquiaga is the author of *Megalopolis: Contemporary Urban Sensibilities*. She grew up in Caracas, Venezuela, and in New York City, where she obtained a Ph.D. from Columbia University in Cultural Studies in 1990. A writer and cultural critic, she teaches literature and film at Cooper Union.

Ismail Serageldin is Vice President for Environmentally Sustainable Development at the World Bank. He has a Ph.D. from Harvard University and is a former member of the Steering Committee of the Aga Khan Award for Architecture. He has written widely on architecture, African issues, urbanism, the Arab world, Islam, and culture.

Jean-Louis Pinte is a journalist and novelist living in Paris. After studying literature he became interested in the cinema and then in journalism. He is now responsible for the "Arts" section of the *Figaroscope*, the cultural supplement of the daily newspaper. Every week he also gives a news summary on current exhibitions on radio Europe 1. He has published two novels: *Les Temps abandonnés*, 1990, and *Les Douleurs de l'oubli*, 1992, both Editions du Mercure, France.

Jean-Marc Patras, after a period of involvement in the promotion and development of American and English rock groups, joined the staff of the magazine *Actuel*, where he covered avant-garde ideas and contemporary culture and came into contact with a number of African artists. In 1988, in his small gallery near the Picasso Museum in Paris, he exhibited the work of Cheri Samba for the first time, followed by other artists from Kinshasa: Bodys Isek Kingelez, Moke, Botala Tala, and others. At present he is working principally with African and Latin-American artists.

Current Donors

Charles B. Benenson
Bernice & Sidney Clyman
Mr. & Mrs. Richard Faletti
Lawrence Gussman
Jane & Gerald Katcher
Drs. Marian & Daniel Malcolm
Adrian & Robert Mnuchin
Don H. Nelson
Mr. & Mrs. James Ross
Lynne & Robert Rubin
Daniel Shapiro & Agnes Gund
Cecilia & Irwin Smiley
Sheldon Solow

William Brill
Alain de Monbrison
Drs. Nicole & John Dintenfass
Denyse & Marc Ginzberg
Helen & Robert Kuhn
Mr. & Mrs. Jay Last
Helen & Philippe Leloup
Mr. & Mrs. Brian Leyden
Lee Lorenz
Maureen Zarember

S. Thomas Alexander
Henry Van Ameringen
Gaston T. de Havenon
Sulaiman Diane
Mrs. Melville W. Hall
Jerome & Carol Kenney
Helen Kimmel
Junis & Burton Marcus
John Morning
Teruko & Herbert Neuwalder
Nancy & Robert Nooter
Mrs. Harry Rubin
Mr. & Mrs. Edwin Silver
Marsha & Saul Stanoff
Thomas Wheelock
James Willis Gallery
Mr. & Mrs. William Ziff

Ernst Anspach
Michael Berger, M.D.
Lynn & Samuel Berkowitz
Damon Brandt
Pam & Oliver Cobb
Frederic Cohen & Diane Feldman
Nancy & Dave DeRoche
Noble & Jean Endicott
Marc Felix
Dr. & Mrs. Gilbert Graham
Rita & John Grunwald
Jaye & Clayre Haft
Regina & Stephen Humanitzki
Leonard Kahan
Oumar Keinde

Reynold Kerr
Stanley Lederman
Barry Maurer
Mrs. Kendall Mix
John Mors
Klaus Perls
Fred & Rita Richman
Dorothy Brill Robbins
Eric Robertson
Mr. & Mrs. Milton Rosenthal
Ana Roth & Abraham Vorster
Hans Schneckenburger
Beverely & Jerome H. Siegel
Mr. & Mrs. Morton Sosland
Steven Van de Raadt & Kathy Van
 de pas
Christian & Sandra Wijnberg
Mr. & Mrs. William Wright

Joan & George Abrams
Marcelle R.S. Akwei
Arnold J. Alderman
Barbara & Daniel Altman
Pierre Amrouche
Ann Anson
Sandy Baker
Neal Ball
Walter Bareiss
Joan Barist
Mrs. Saretta Barnet
Armand Bartos, Jr.
Ralph Baxter
Sallie & Robert Benton
Sid & Gae Berman
Anita Birkland
Jean Borgatti & Donald Morrison
Rev. Raymond E. Britt, Jr.
John A. Buxton
James G. Caradine
Lenore Casey
Jill & James Cash
Joyce Chorbajian
Carroll & Katherine Cline
Jeffrey Cohen & Nancy Seiser
Eileen & Michael Cohen
Betsy & Alan Cohn
Joel Cooner
Mr. & Mrs. Herman Copen
Annette & DuVal Cravens
Marie-Eliane d'Udekem d'Acoz
Grassi Daniele
Gerald & Lila Dannenberg
Rodger Dashow
Peggy & Gordon Davis
Carl A. De Brito
Count & Countess Bernard De
 Grunne
Mary & Kurt Delbanco
Bunny & Jeff Dell
Jill Dempsey

Morton Dimondstein
Norman & Shelly Dinhofer
Nancy B. Doan
Dr. & Mrs. Aaron H. Esman
John Falcon
George & Gail Feher
Kate & Newell Flather
Donald & Serene Flax
Charles Flowers
Gordon Foster
Mr. & Mrs. Charles Frankel
Marc & Ruth Franklin
Dr. & Mrs. Murray B. Frum
Clara K. Gebauer
Walt Gebauer
Michael George
Mary Gibson & Harry Kavros
Mr. & Mrs. Joseph Goldenberg
Audrey & Arthur Greenberg
Irwin E. Gross
Jimmy Hancock
Alan Helms
Janine & Michael Heymann
Elizabeth R. Hird
Steven Hyman
Bernard & Fern Jaffe
Judith & Harmer Johnson
Lucy Black Johnson
Christiaens Joseph
Jerome L. Joss
Margaret Kaplan
Janet Karatz
Jacques Kerchache
Jill & Barry Kitnick
Joseph & Margaret Knopfelmacher
Leslie & Linda Koepplin
Alvin S. Lane
Roxanne & Guy Lanquetot
Alida & Christopher Latham
Jay C. Leff
Nancy Lensen-Tomasson
Guylene Lindquist
Richard & Mimi Livingston
Gerbrand Luttik
Lester & Joanne Mantell
Vivione Marshall
Sally Mayer
Lloyd & Mary McAulay
Mr. & Mrs. John McGee
Hon. John A. McKesson
Jane B. Meyerhoff
Marguerite Michaels
Peter & Nancy Mickelsen
Sam Scott Miller
Cavin-Morris, Inc.
Florence & Donald Morris
Professor Marshall Mount
Werner Muensterberger
Charles J. Mus
Judith Nash

Mr. & Mrs. Milford Nemer
Roy R. & Marie S. Neuberger
Teruko & Herbert Neuwalder
Peter Norton
Jack Odette
Michael Oliver
Carolyn Owerka & Alyasha
 Owerka-Moore
David T. Owsley
Margaret Pancoast
Francesco Pellizzi
Professor & Mrs. John Pemberton
Linda C. Phillips
E. Anne Pidgeon
Mr. & Mrs. Joseph Pulitzer, Jr.
Ana Ricart
Beatrice Riese
Betty J. Roemer
William Jay Roseman
John B. Rosenthal
Elsa & Marvin Ross-Greifinger
William & Joan Roth
Barbara Rubin
Mrs. Stephen Rubin
Arthur & Joan Sarnoff
Stephen K. Scher
Franyo Schindler
Eleanor & Herbert Schorr
Sydney L. Shaper
Shirley & Ralph Shapiro
Mary Jo Shepard
Carol Spindel & Tom Bassett
Barbara H. Stanton
Lucille Sydnor
Howard Tanenbaum
Ellen Napiura Taubman
Farid Tawa
Mr. & Mrs. William E. Teel
Edward Thorp
Lucien van de Velde
Prof. Jan Vansina
Carolyn Carter Verleur
Anthony & Margo Viscusi
Nils von der Heyde
Dr. & Mrs. Bernard M. Wagner
Frederic & Lucille Wallace
Dr. & Mrs. Leon Wallace
Allen Wardwell
Stewart J. Warkow
Shelley Weinig
Monica Wengraf-Hewitt
George F. Wick
Mr. & Mrs. O.S. Williams
Ruth E. Wilner
Ruth M. Ziegler

Loans to the Exhibition

The works of Aboudramane are all lent by the artist except for *La Maison ronde*, lent by André Shoeller, and *La Grande Mosquée*, lent by Cavin-Morris Inc. The works of Bodys Isek Kingelez are all from the collection of Jean-Marc Patras.

Photo Credits

All objects were photographed by Nguyen Tien Lap except for *La Grande mosquée*, photographed by Jerry L. Thompson. Portrait photograph of Aboudramane was taken by Catherine de Clippel.